11/14

BLAZE ORANGE

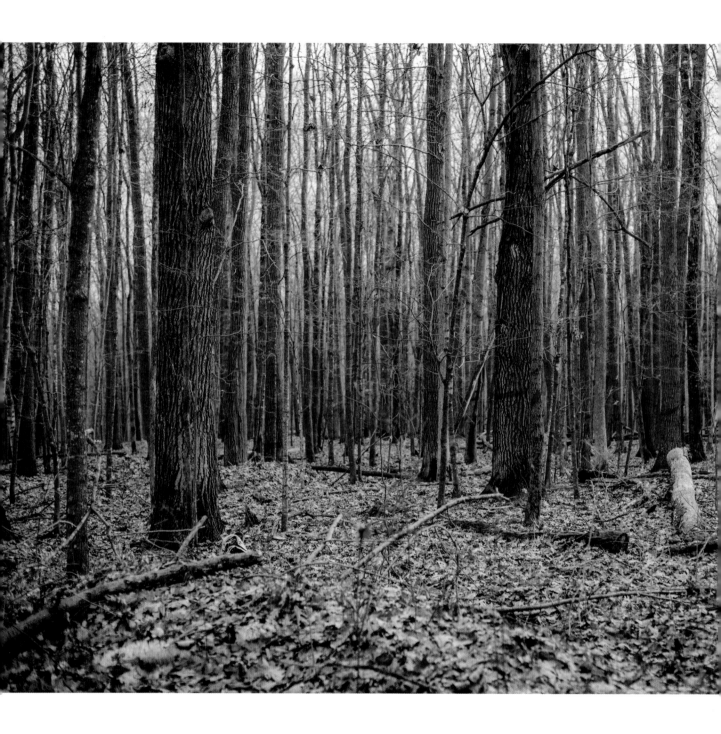

BLAZE ORANGE

Whitetail Deer Hunting in Wisconsin

TRAVIS DEWITZ

Wisconsin Historical Society Press

Published by the Wisconsin Historical Society Press
Publishers since 1855

Text and images © 2014 by Travis Dewitz
Foreword © 2014 by Thomas H. Garver

wisconsinhistory.org

Printed in Wisconsin, USA
Designed by Percolator Graphic Design

18 17 16 15 14 1 2 3 4 5

Library of Congress Cataloging-in-Publication Data
Dewitz, Travis, 1979–
 Blaze orange : whitetail deer hunting in Wisconsin / Travis Dewitz.
 pages cm
 ISBN 978-0-87020-668-9 (hardcover : alk. paper) — ISBN 978-0-87020-669-6 (e-book) 1. White-tailed deer hunting—Wisconsin. 2. White-tailed deer hunting—Wisconsin—Pictorial works. I. Title.
 SK301.D42 2014
 799.2′7652—dc23

 2014007113

⊗ The paper used in this publication meets the minimum requirements of the American National Standard for Information Sciences—Permanence of Paper for Printed Library Materials, ANSI Z39.48-1992.

Acknowledgments

I would like to express my most heartfelt gratitude to the following people:

First, to everyone at the Wisconsin Historical Society Press, for seeing the potential in my book and choosing to publish it. A huge thank-you to all of those involved in its creation, in big or small ways.

And to all the people who gave permission to me to photograph them, for allowing me into your lives if only for a short time and letting me share in the various moments of your deer hunting season. Your cooperation and generosity made this book possible.

Finally, to my friends and family, for all the love, support, and encouragement you gave me throughout this process.

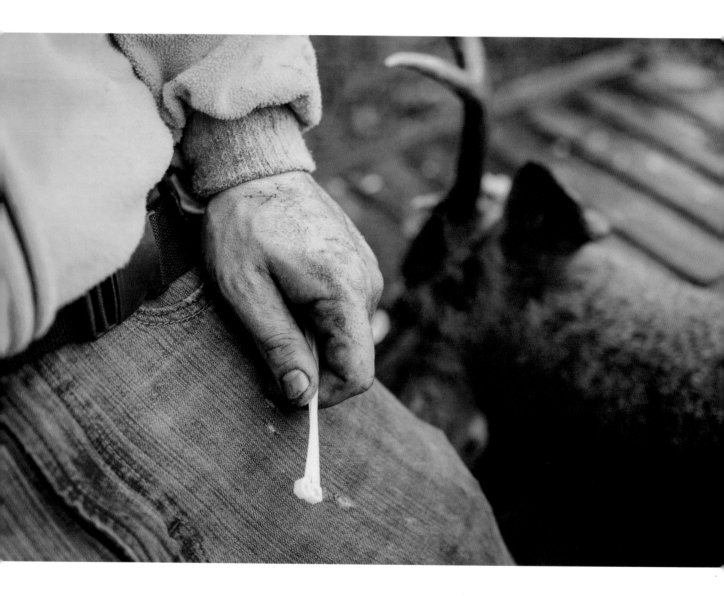

A Prepared Mind and the Blaze Orange Army

BY THOMAS H. GARVER

A lifelong resident of the Eau Claire area of west-central Wisconsin, Travis Dewitz is in willful possession of three seemingly conflicting professions. Through intensive study and regular training, he is an automotive diagnostic technician, one who is so knowledgeable of the computers in modern automobiles that he is busy both in the family automotive shop and on frequent calls to other mechanics to resolve complex electrical problems. Dewitz is also a full-time commercial photographer, an art in which he is entirely self-taught. He has developed through repetition, self-examination, and intense analysis a subtle skill at composition. He possesses a deep understanding of "photographic vision," the awareness that what one sees and how the camera may record it can be very different and subject to careful manipulation. He photographs weddings, produces portraits for high school seniors, and documents places, people, and events as he is commissioned.

These two jobs provide a very full day's work and reasonable remuneration, but it is Dewitz's other profession, perhaps better described as an obsession, which is of most importance here. Dewitz is a "diarist-photographer," telling stories and sharing visual experiences as a way of diffusing his unique point of view into a wider field. He records places and events of deep interest to him, even when they are far distant from his normal sphere of activities, often posting his work on his website. These written and visual narratives range widely, from agricultural and industrial sites to subjects seen within a much smaller field— the record of a deteriorating Pennsylvania steel town or the fleshly intimacy of

female tattoos. Dewitz creates these photography projects to fulfill his personal need to create. His mantra is, "My best photographs are still out there. I'm always chasing those images."

Whenever he can get away—and sometimes alongside his other work, as on annual training trips he takes to Kansas City for his automotive career—Dewitz heads out in search of subjects for his camera. His time constraints demand that he know in advance what he wants to photograph and be prepared to work rapidly. One year found him in Williston, North Dakota, to document the oil and gas boom taking place in the Bakken formation. Another trip took him to the coal fields of the Powder River Basin in Wyoming, and a third brought him to southern West Virginia, where he recorded derelict coal towns and the rail lines that serve the region, railroads being his favorite and most heavily photographed subject.

The Wisconsin gun deer hunt didn't fit Dewitz's daily schedule either, but it is an experience he remembers with nostalgia from his childhood. Each year, the hunt lasts only nine days, a moment in time at the end of November. Remarkably, Dewitz took just six days to capture the event in 2012, and each night he slept in his own bed. The efficiency and clarity of his vision are particularly marked when seen against the magnitude of the Wisconsin deer hunt itself, which is without doubt the largest statewide activity of the year. In 2012, almost 635,000 people bought a gun deer hunting license, donned the uniform of the blaze orange army, and headed out into the woods and fields of the state.

In contemplating and planning the project, Dewitz sought first to record it in as "timeless" a way as possible and to show a number of the ancillary activities that exist because of the deer hunt—butchering, processing hides, making knives. But, for all of the people and movement and happiness and disappointment of this enormous event, what Travis Dewitz has created is a multifaceted portrait of intergenerational intimacy and comradeship. Hunting deer is a real experience, a blood sport (with a good deal of blood to be seen), conducted with one's friends and family. It may be a game, but it is one not played on the digital simulacrum of the screen. Today, the hunt is one of the few times and places, other than religious services or Thanksgiving, where generations truly mix with each other, and Dewitz's portraits of several generations standing together, or of young hunters with their guns, proud and shy and maybe just a little scared too, are among his best images.

Dewitz has also captured so well the muster points for this army, the country taverns, cafés, and grocery and general stores that are utterly devoid of any "style," save what the powerful accretions of time have provided. All those antlers and heads on the walls are not there just to hold the Christmas lights; they form a skein of local history because each one marks a pinnacle moment for someone in the community, an icon of great personal importance and an object of reflection, there to be seen and remembered year after year.

The Wisconsin gun deer hunt is a deeply felt ritual in the state, one that is held in delicate balance by the conservation of wildlife, of which the hunt is one facet. But beyond that, Wisconsin's Department of Natural Resources has found that the two most important elements drawing hunters back time and again into the woods and fields are seeing, and hopefully shooting, deer, and sharing in the community of family and companions assembled only for this brief moment each year. These are the memories of the hunt that Travis Dewitz recalls with nostalgia, and it is this record, in the field and back at the camp, or store, or tavern, that he has documented so well.

THOMAS H. GARVER *has been involved with American art and photography for more than fifty years, most recently serving as organizing curator of the O. Winston Link Museum in Roanoke, Virginia, the only museum in the United States devoted to the work of a single photographer. Prior to that, Garver was director of the Madison Art Center (now the Madison Museum of Contemporary Art) from 1980 to 1987. Now retired, he and his wife live in Madison, Wisconsin.*

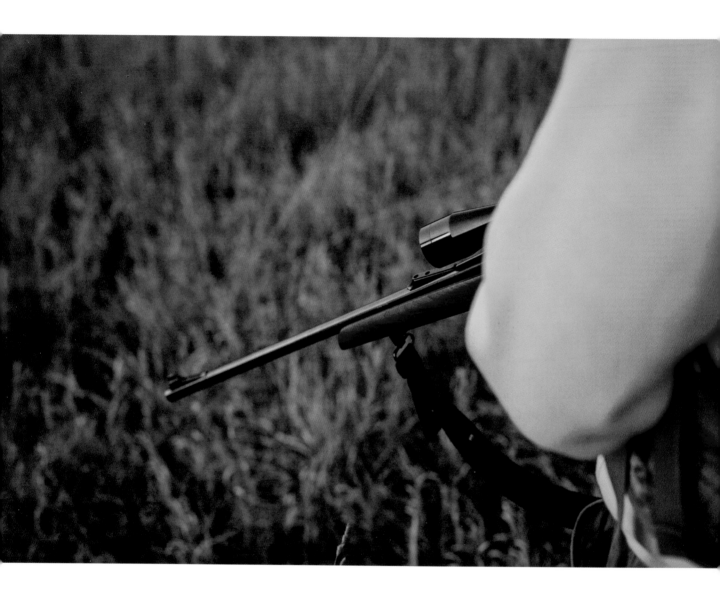

Introduction

Every year, as I start to see blaze orange everywhere I go, I feel nostalgia for the times I spent in the woods when I was young—the leaves falling to the ground, the cool weather and light breezy days, the sounds and peacefulness of nature. I seem to remember the few mild hunting years of my childhood more than the harsh, cold, snow-covered ones. Before I could hold my own gun, I would ride across the countryside of central Wisconsin with my dad as he drove to his hunting spot, never the same place as the year before. Sometimes we just drove hoping to see a deer.

Once I was old enough, I completed and passed a hunter safety class. Then the trips became longer and more involved. We would pack the trailer for the weekend and head up north to a camp. When we arrived, we would unload our gear and spend a little time around the woodstove with friends we hadn't seen since last year, talking over our plans for opening morning, enjoying old stories, and catching up with each other. It felt like only a few months had gone by instead of a year.

The next morning, the alarm blared out well before I was ready to meet the day. My dad would flick on a small light that gave off a warm glow, at first blinding but then just enough to get ready in. Soon I would be walking the trail toward the spot I had picked for opening morning, a spot I returned to every year I hunted at that camp. The small circle of light from my flashlight barely cut into the pre-dawn darkness. Without vision, my ears magnified the sounds around me. My footsteps were loud, every step crunching against the ice-encrusted snow. Even

a slight breeze sounded like a hurricane blowing through the woods as the dry, dead leaves rattled against each other.

Soon I would get to my spot and wait for daybreak. The darkness slowly lightened into a dark blue about an hour before sunrise, and as the woods brightened I could start to make out the trees. My ears were tuned for that distinctive soft sound of deer hooves moving across the forest floor, though I was often tricked by a light breeze or a small forest animal. The sun eventually broke past the horizon and flooded through the trees as the first gunshots rang out across the countryside. This was deer hunting.

I'm a bit older now, and I don't go hunting as much as I used to, but the culture of the sport and its atmosphere are deeply felt around my home in Wisconsin. I wanted to capture with my camera what I experienced growing up and what I still see among my friends and family whenever late November comes around.

This photographic journey started well before the opening of the gun deer season. I had to sit down and plan how I would show what deer hunting is. How was I going to convey those moods I felt as a child? How could I depict that feeling of being in the woods, in the cold, as the sun rises on opening morning? How would I show the bonds between the hunters and among the tight-knit families who go out together?

I decided I needed to focus on the human element as the core of my photography. To me, deer hunting will always be about family and tradition. I wanted to show groups of hunters sharing the experience with one another. The rest, I thought, would fall into place.

I arranged as many connections as I could. I contacted hunters I know to set up times I could join them in the woods. These connections gave me anchor points all around Wisconsin where I could spend a couple hours with a group and follow them.

Opening day came quickly. I actually started the night before with a group south of Eleva, Wisconsin. Each day I covered a portion of the state. Most of the time, I included those anchor points where I knew people for solid photo opportunities. But some mornings I just drove to a location I liked and looked for hunters. I found them leaving their farms, or preparing to walk a field or head into the woods to a tree stand. If someone looked busy or in a hurry, I wouldn't

bother them. Other hunters I would walk up to, quickly explain what I was doing, and ask for a few minutes of their time.

I didn't know what to expect from the hunters. What would they think of me, a stranger, walking up to them during deer season without a rifle and holding a camera? I was prepared for my requests for photographs to be turned down. Instead, I was warmly welcomed by everyone. Many of the hunters were very interested in what I was doing and pulled me right in. I felt like I was with family among some of the groups. Usually, we were only together a few minutes since I didn't want to intrude more than I needed to. Other groups I spent hours with.

I filled whole days driving from one location to another. I would photograph a hunter off in the distance, stop at a check-in station, drive to one of my planned anchor points, stop by a group on the side of the road, and then maybe walk out into the woods with a lone hunter I met in the next county over. I continued searching for places and subjects until about an hour after sunset. Then I would drive back home to prepare for my next day. In the course of the entire season, I came across hundreds of hunters and did not have any bad experiences. Only a couple of them didn't want to participate and politely said no thank you.

But deer hunting isn't just a nine-day event; it encompasses a large support staff before and after the hunt. I wanted to include as much of this aspect of hunting as I could—the people who forge knives, sell deer licenses, repair guns, mount trophies, and make sausages. I could go out to many of these businesses before or after the season. I photographed the knife maker a couple of months early. The taxidermist was photographed on multiple trips before and after the season. The butcher shop was also time sensitive, and I needed to photograph it after the hunting was over, while they were processing the venison. I chose places that had a timeless feel to evoke memories in the viewer. Many places I stopped I remembered from my childhood. This part of the project was very enjoyable. I was able to go on road trips to places I had never been. I joined various communities, however briefly, and I was able to sit down and enjoy real food, not just fast food.

This project was successful because of all the people who let me into their lives. All of the preparation I made before the deer season just gave me a loose plan to follow and allowed me to roll with any changes that came up. When a decent snowfall was predicted for northern Wisconsin, I had to alter my plan.

What's deer hunting without snow? I switched around almost a whole week so I could get up north. The blaze orange snapped off that pure white backdrop of freshly fallen snow.

Working on this project brought back all the feelings I remembered from my own hunting trips—smelling the pines as a sharp cool wind would push against my face. I tried to show these emotions through my photographs. I was on the hunt again that season, carrying a camera instead of a gun, searching for hunters instead of whitetail deer.

BLAZE ORANGE

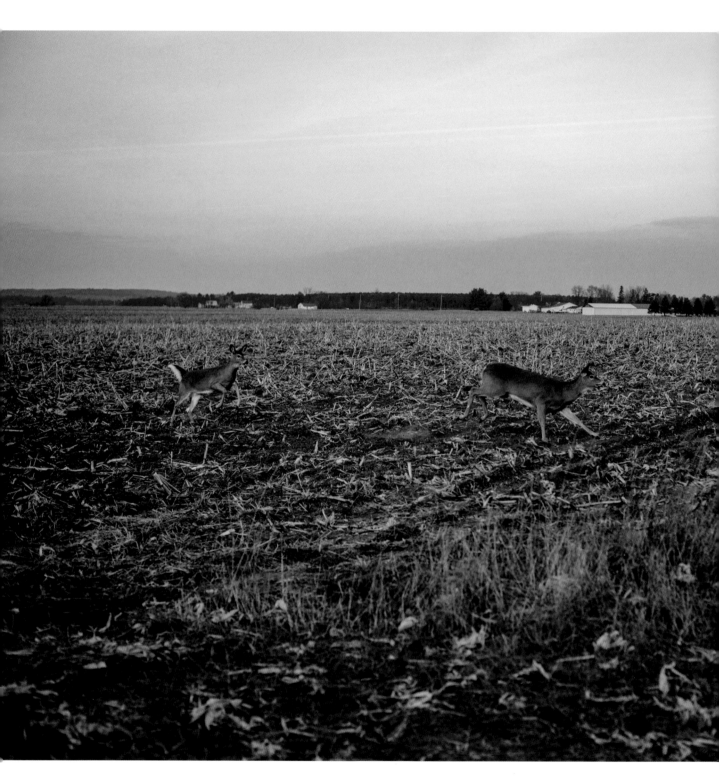

Deer crossing an open field
in the morning light

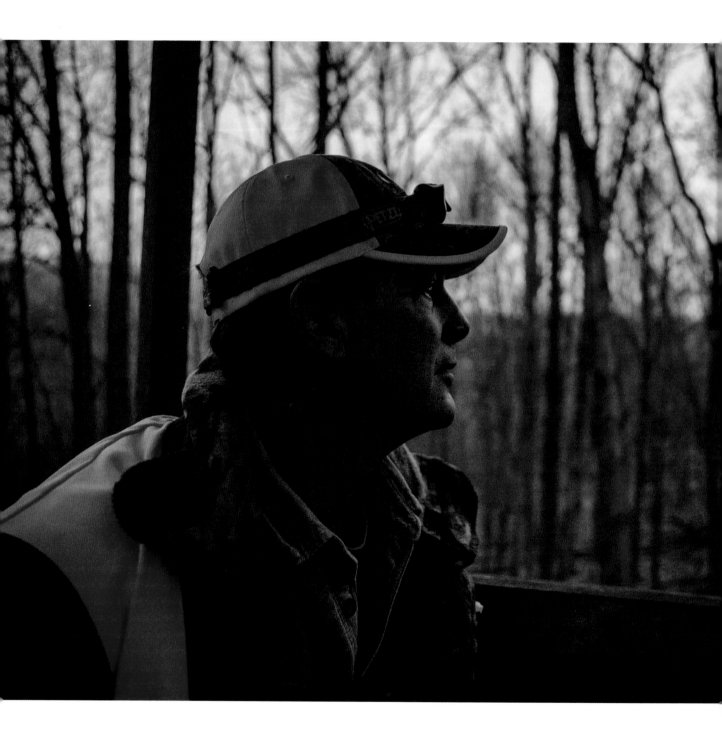

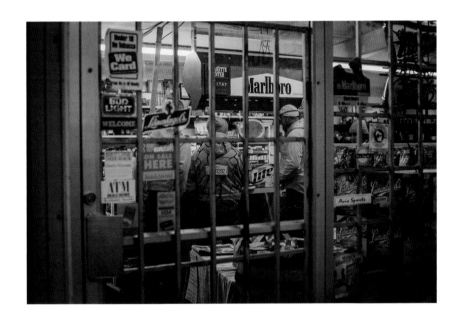

LEFT: A hunter sits high in a tree stand before sunrise on opening morning. ABOVE: Hunters prepare for the day inside OW Sports & Liquor in Owen.

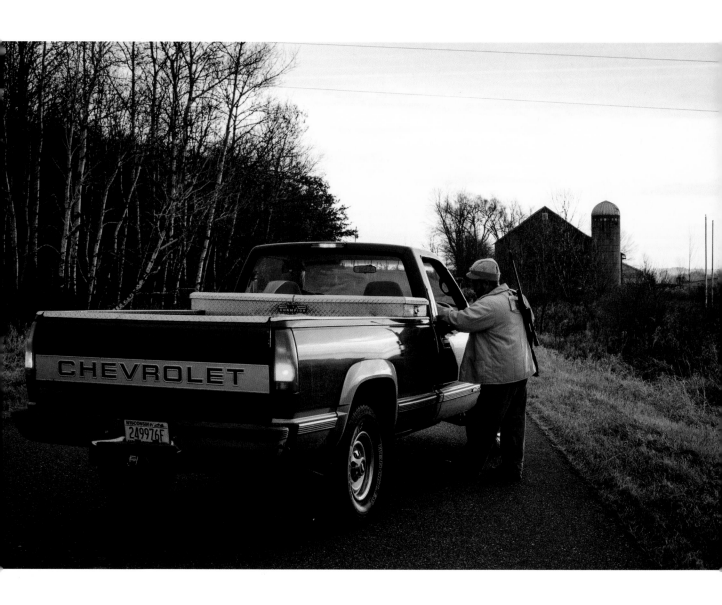

Roc in Bloomer pauses to chat
with a neighbor before he walks
the edge of his land.

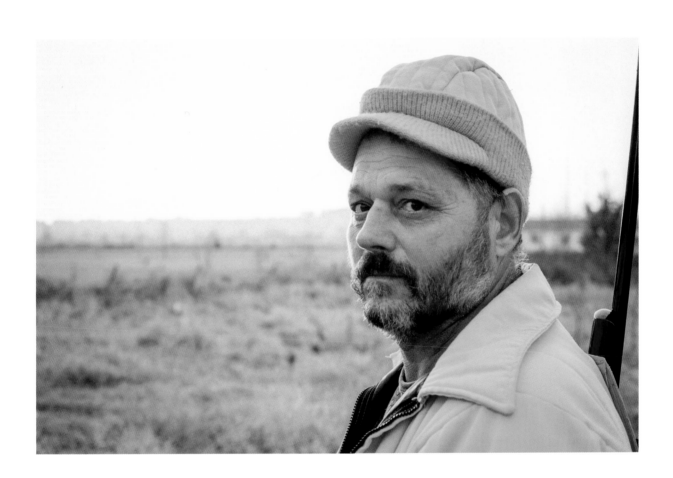

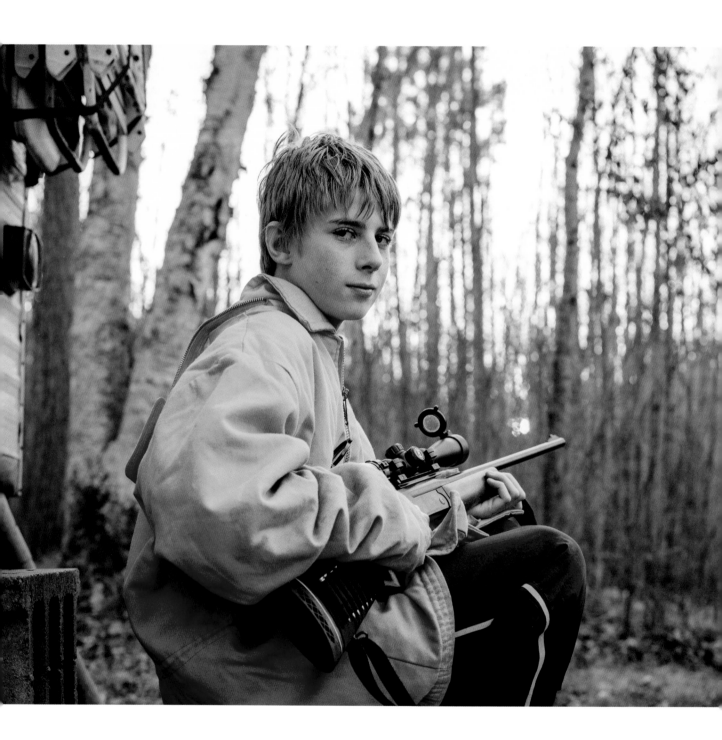

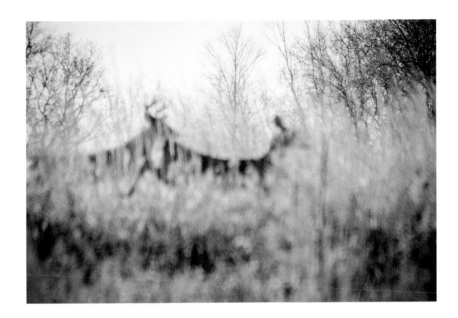

A young hunter sitting
ready back at camp

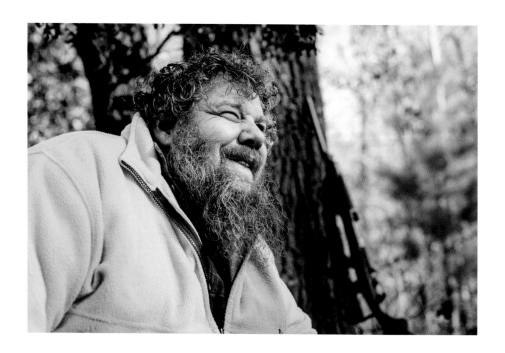

I listened as this hunter
explained the importance
of passing down the values
of hunting to his family,
including teamwork and
responsibility.

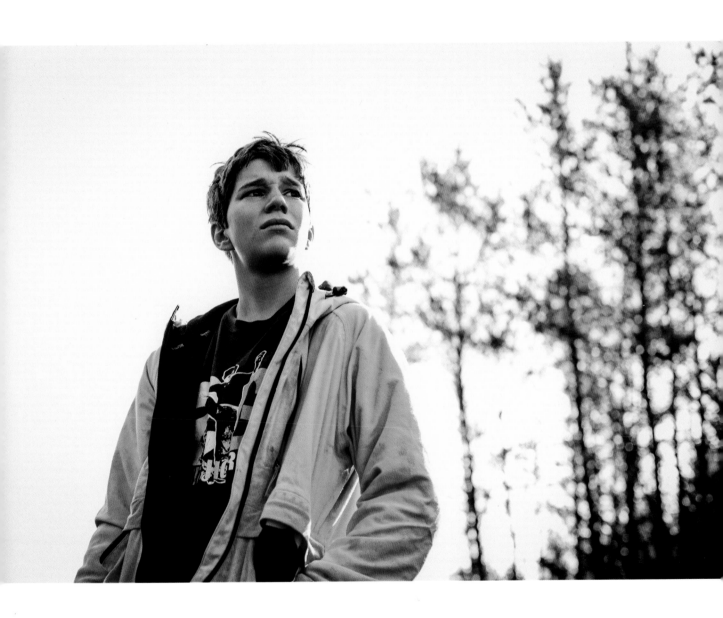

Looking down the dirt road
for the rest of the party to
return from the drive

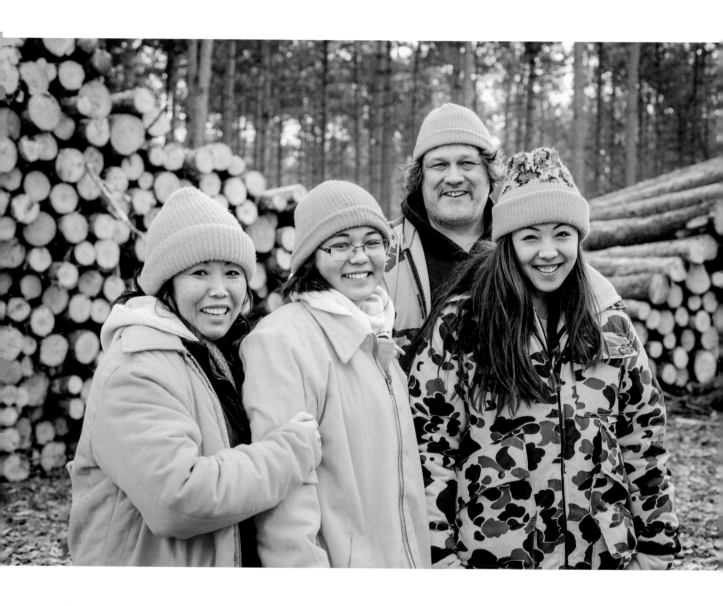

The Kolmer family, just before splitting up
into pairs to walk their wooded property
in northern Dunn County

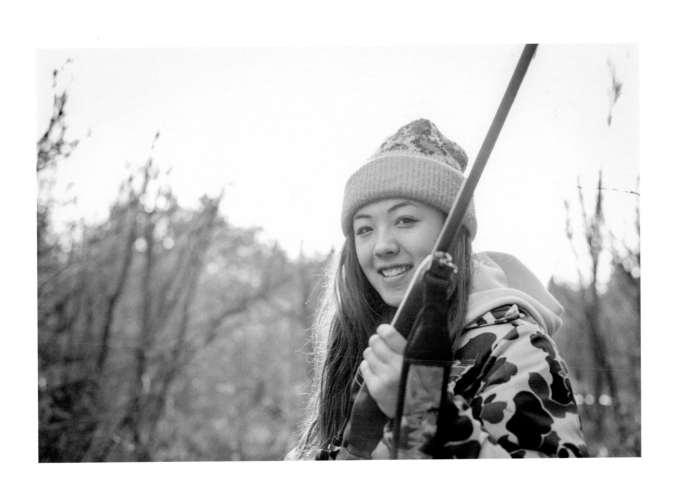

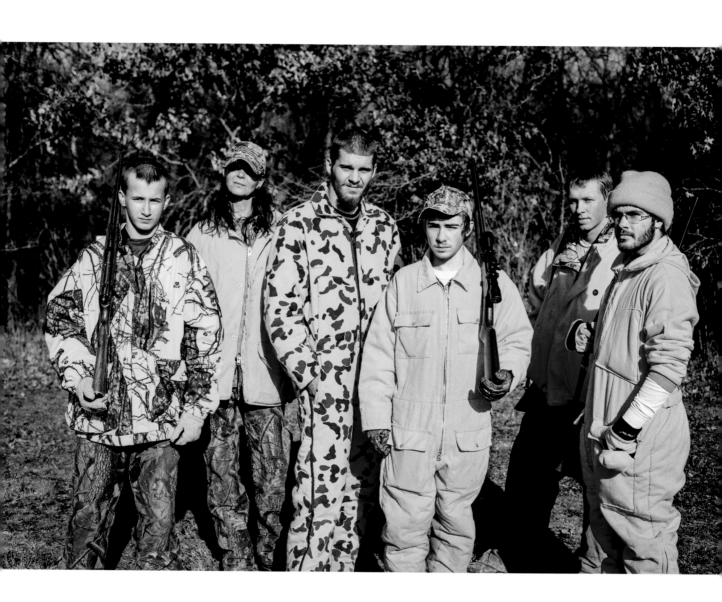

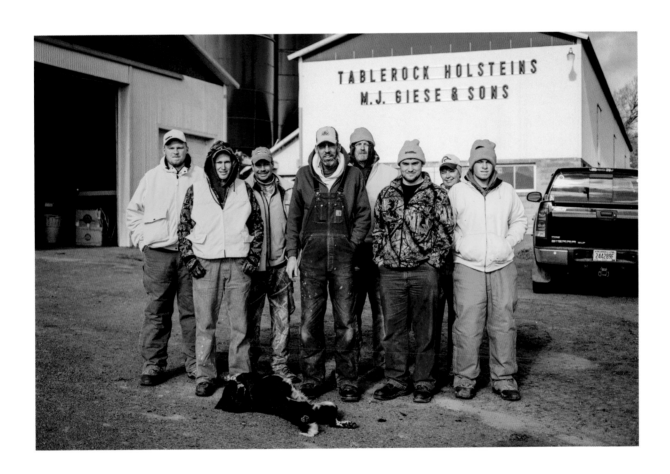

OPPOSITE: A group of friends on the last day of the season in Hixton. ABOVE: Friends and family gather at Tablerock Holstein farm near Alma Center.

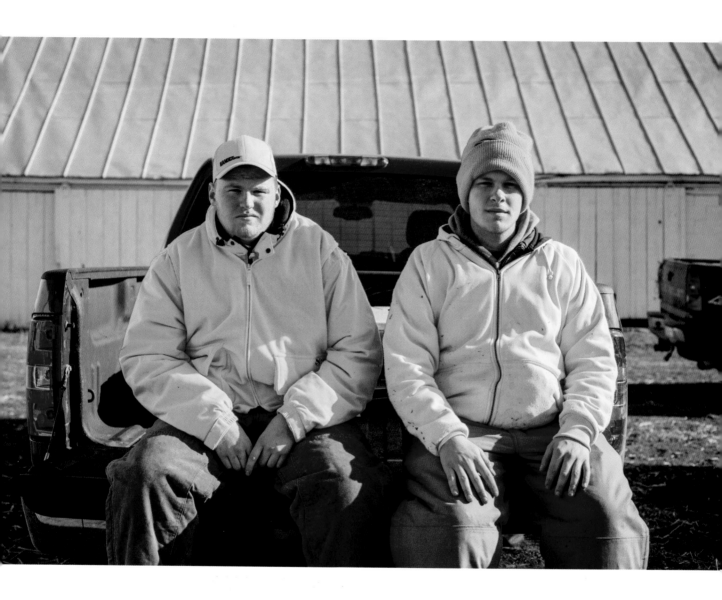

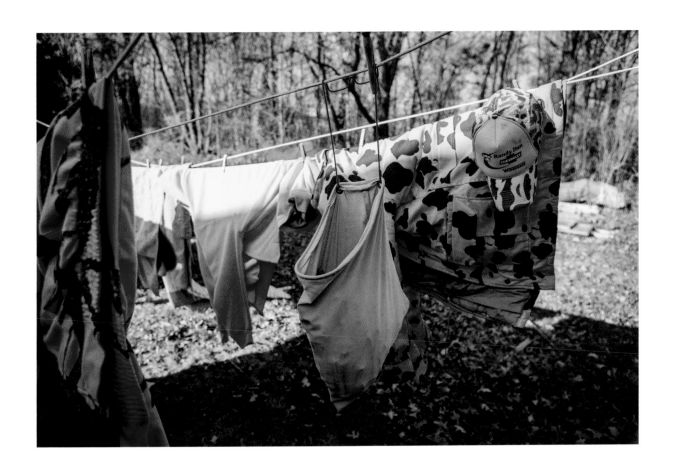

OPPOSITE: Two young men wait to head out on the hunt. ABOVE: A sagging clothesline filled with blaze orange— a common sight during the season

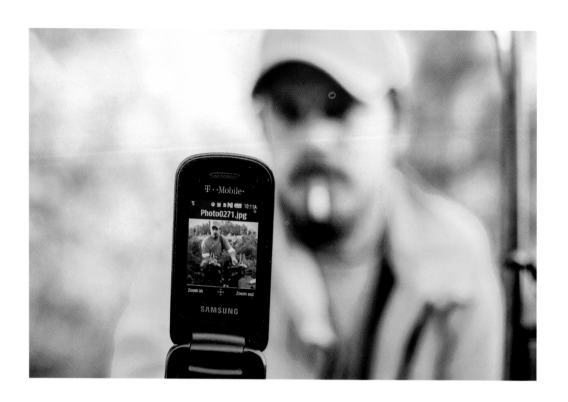

Last year's trophy buck.
Many hunters showed me
evidence of their success
on camera phones, the
new Polaroid.

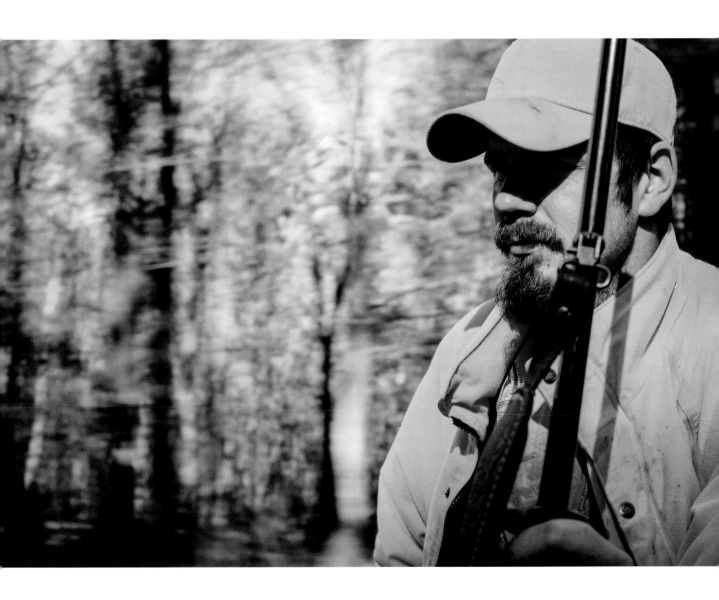

On the move in
Coon Fork Barrens

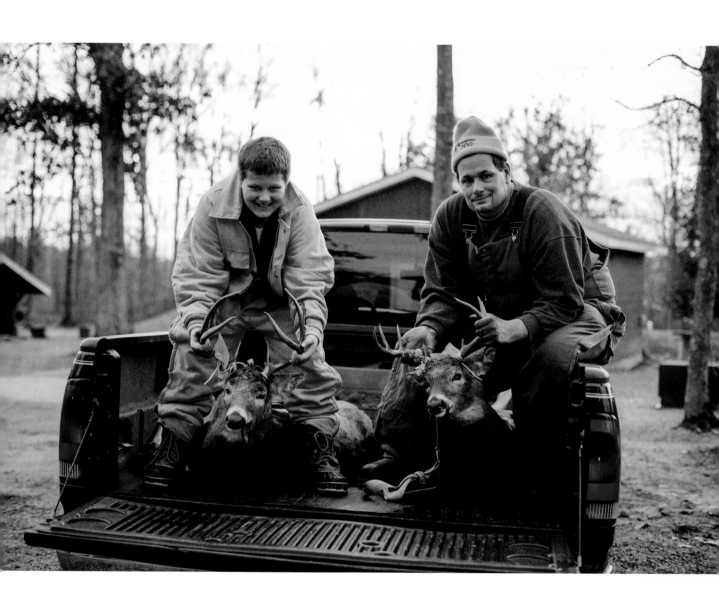

A father and son happily
display their bucks shot in
the Clark County Forest.

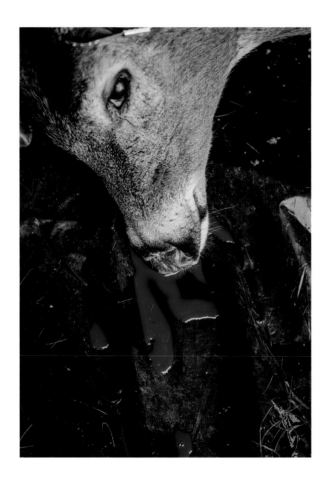

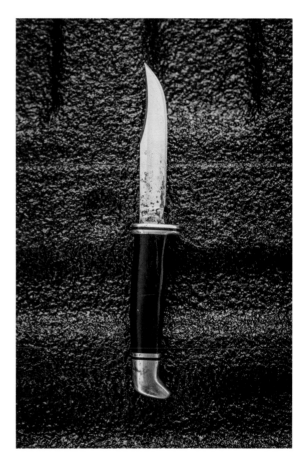

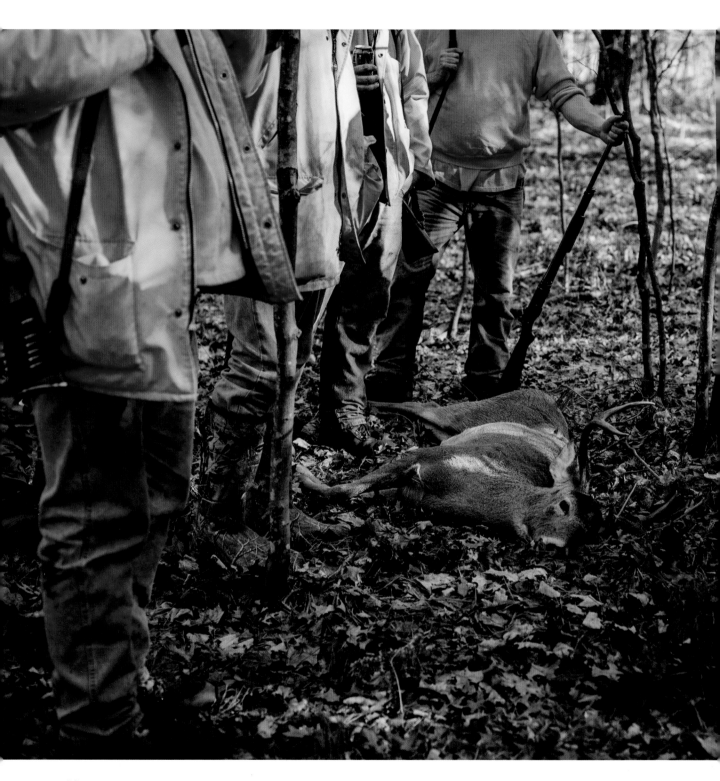

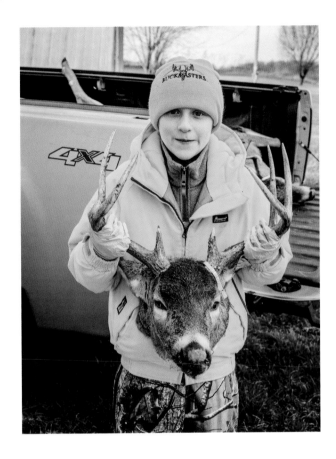

LEFT: A deer drive ends with a group of hunters gathered around a large buck. The camaraderie of hunting brought smiles and congratulations to the lucky shooter. ABOVE: A young hunter holds up the biggest buck from opening day, south of Eleva.

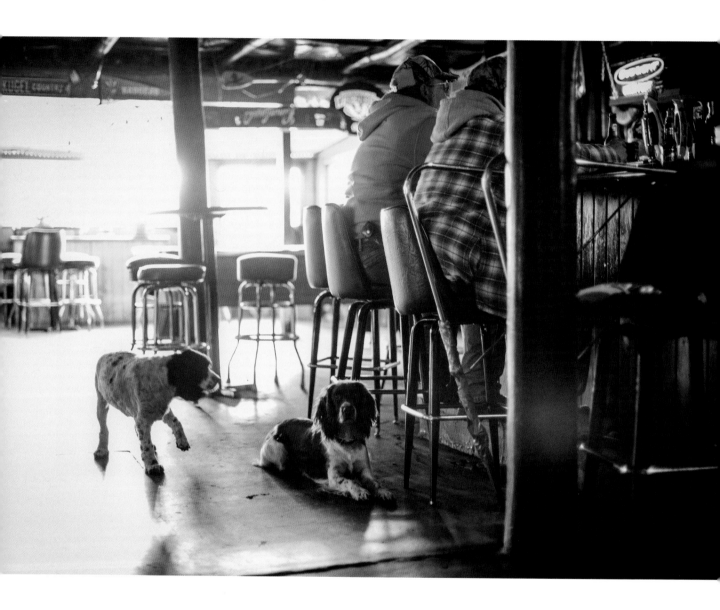

Two Spaniels enjoy the
company at Birch Point
Resort in Bloomer.

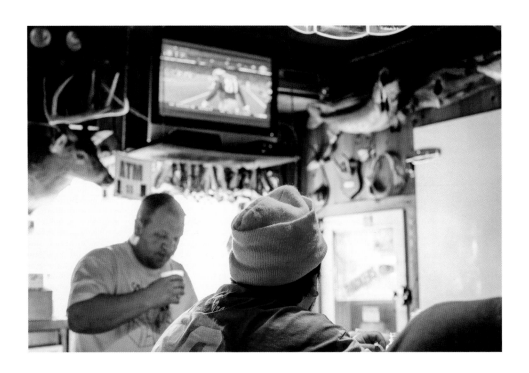

LEFT: Blue Gill Bar, Birchwood.
ABOVE: All over Wisconsin, the woods empty as orange-clad hunters head inside to watch their other passion, the Green Bay Packers, shown here playing the Detroit Lions. Chit Chat Bar, Grill, and Resort, Edgewater.

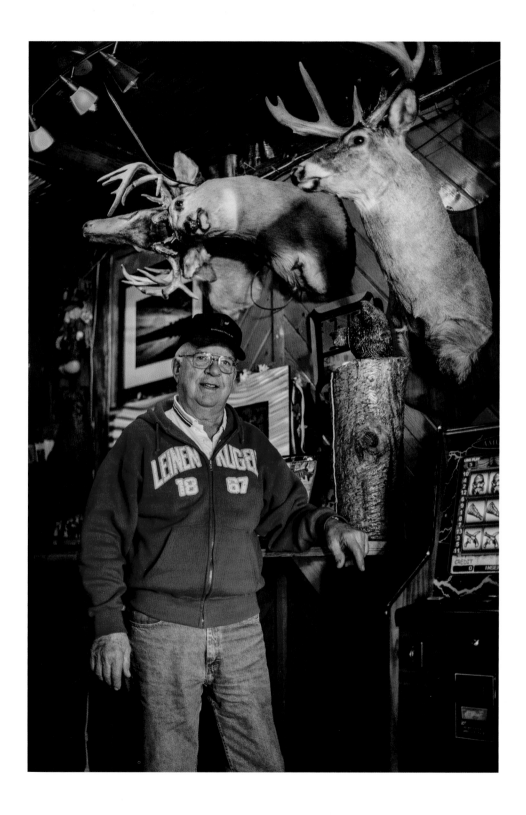

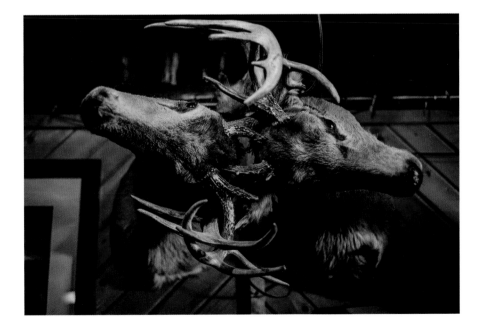

OPPOSITE: Denny stands near the mount of a deer he shot many years ago. It now hangs inside Birch Point Resort, Bloomer. RIGHT: As the story goes, the two deer in this mount were found dead and locked together on the north side of Marsh-Miller Lake, on which Birch Point Resort sits, in the 1970s.

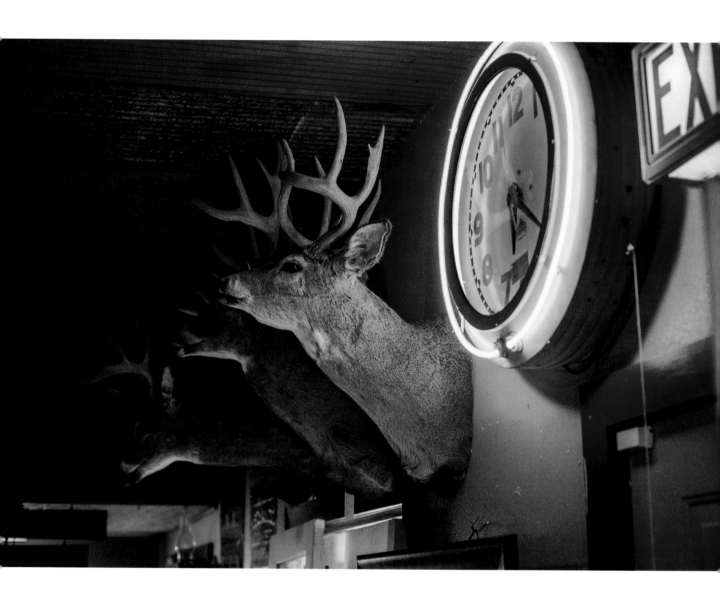

ABOVE: Three buck mounts hang on the wall of Miller's Antiques and Auction Company, Hixton. OPPOSITE: The hallway to the head at Chit Chat Bar, Grill, and Resort, Edgewater

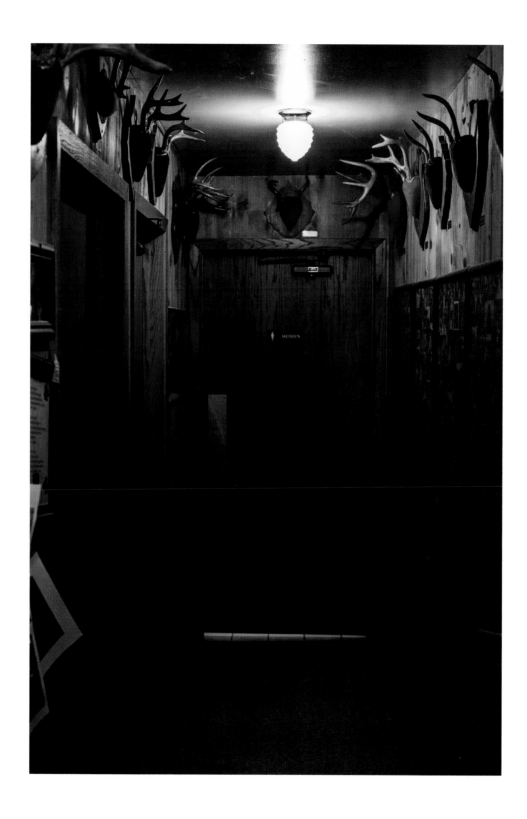

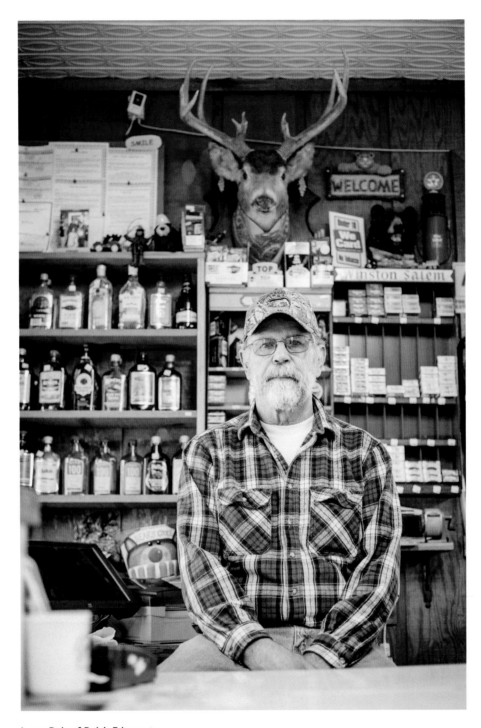

Larry Bair of Bair's Edgewater
Store in Birchwood

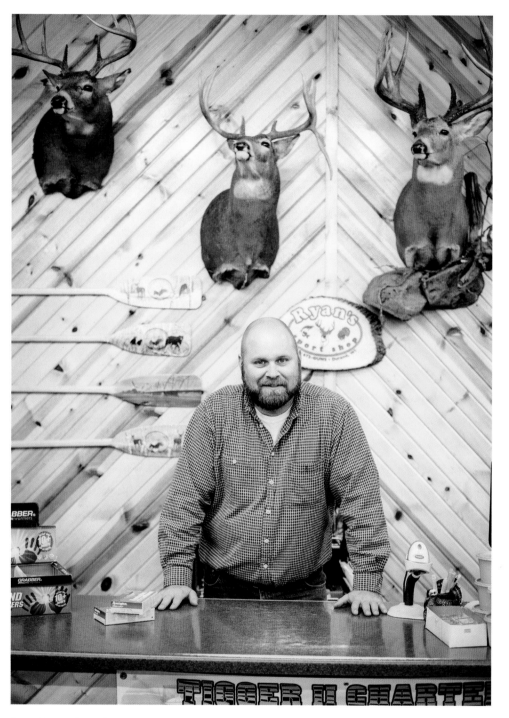

Ryan Casey of Ryan's Sport
Shop in Durand

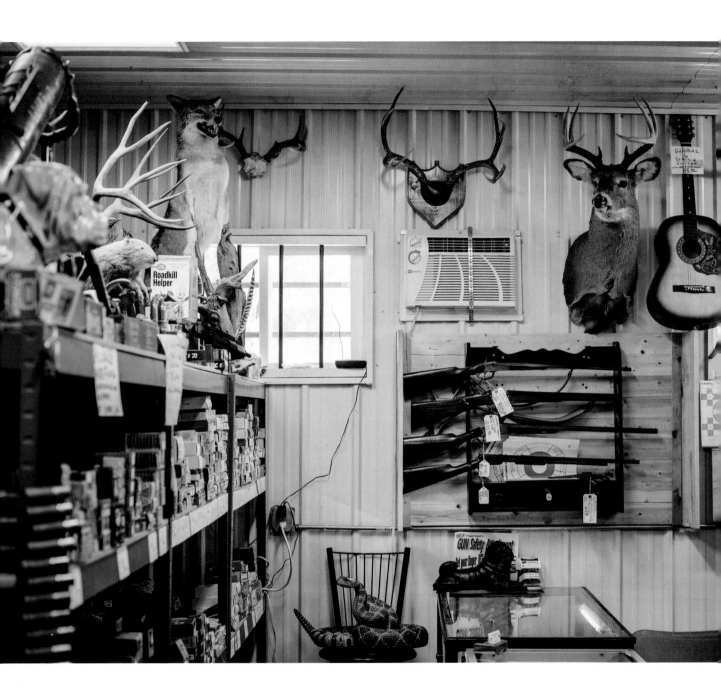

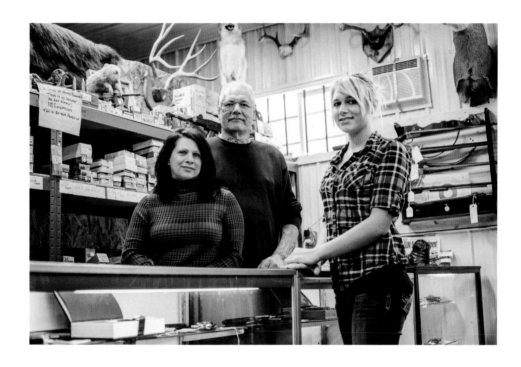

Chicago Bob's TV Repair and Gun Shop in Augusta. Chicago Bob's displays the unique character of many local family-run businesses. Glass cases are filled with vintage items and collectibles, and guitars and animal mounts adorn the walls.

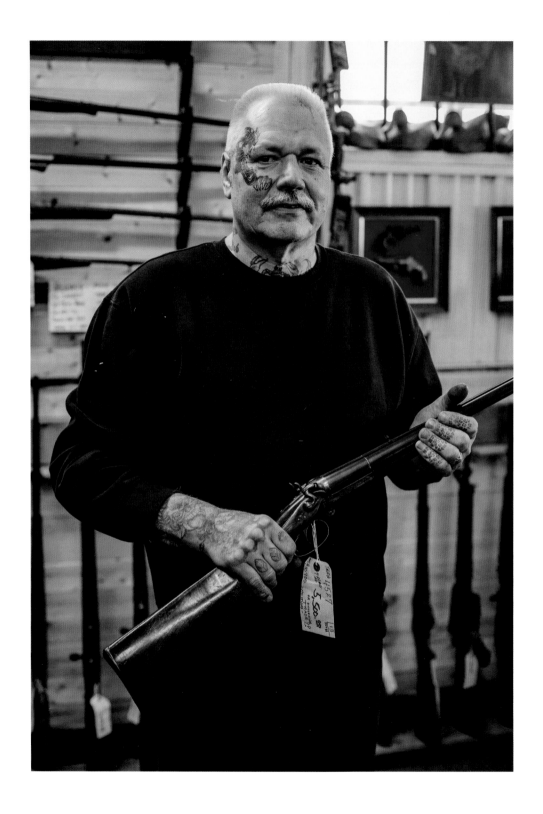

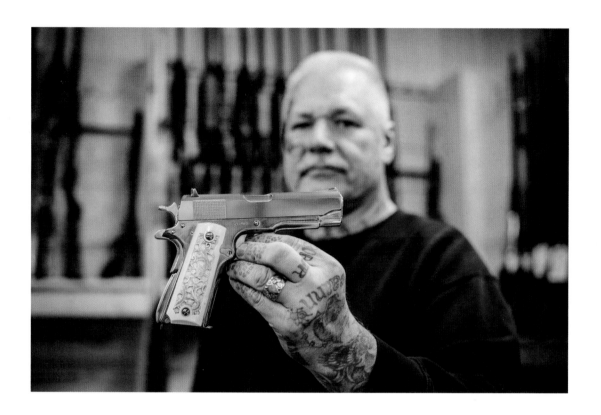

Chicago Bob shows
off some of his prized
items, an antique
rifle (opposite) and a
gold-plated handgun.

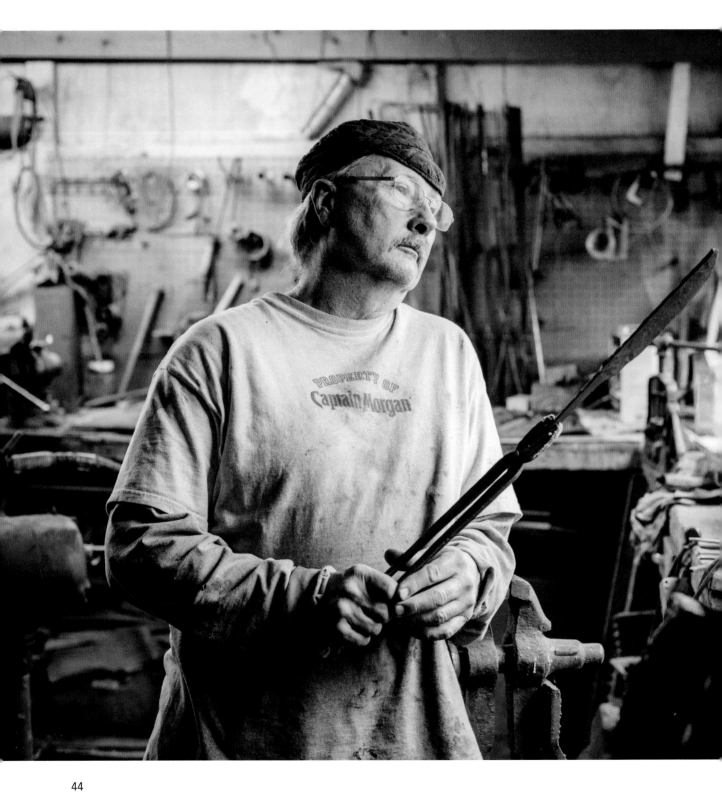

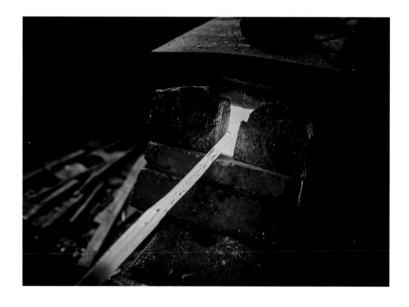

Fred Bruner of Bruner Blades
in Fall Creek holds a steel
knife blank up to the light to
inspect his work.

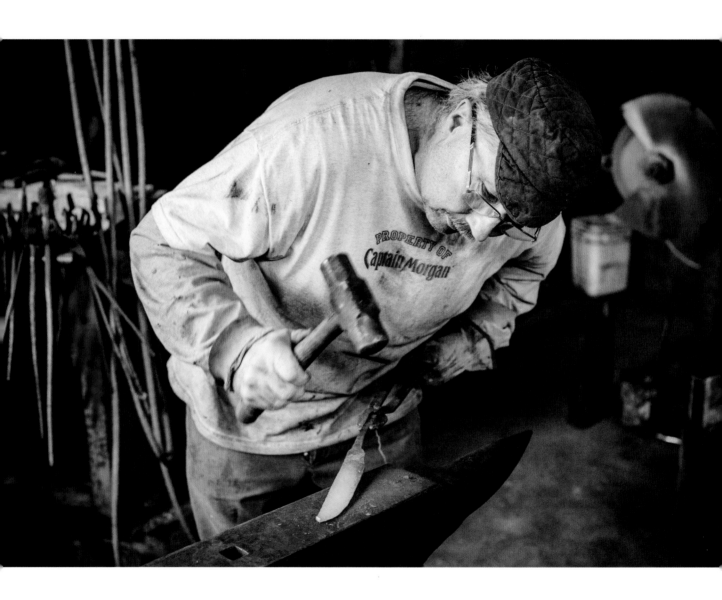

Fred uses hammer and heat
to shape the knife blank.

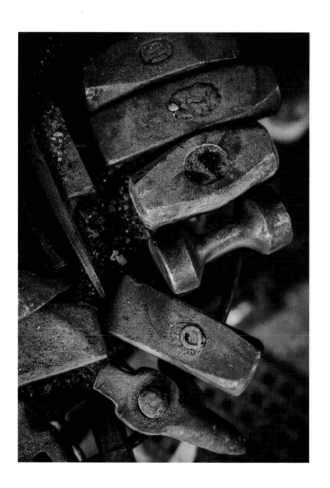

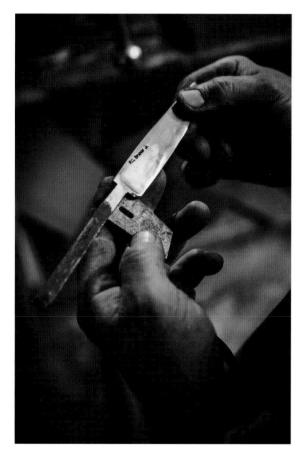

ABOVE, LEFT: Hammers are the essential tool of a metal craftsmen's trade.
ABOVE, RIGHT: After the blank has been refined and polished, Fred cuts and fits the brass guard, using a file to make small adjustments. Once the fit is perfect, the guard is soldered into place.

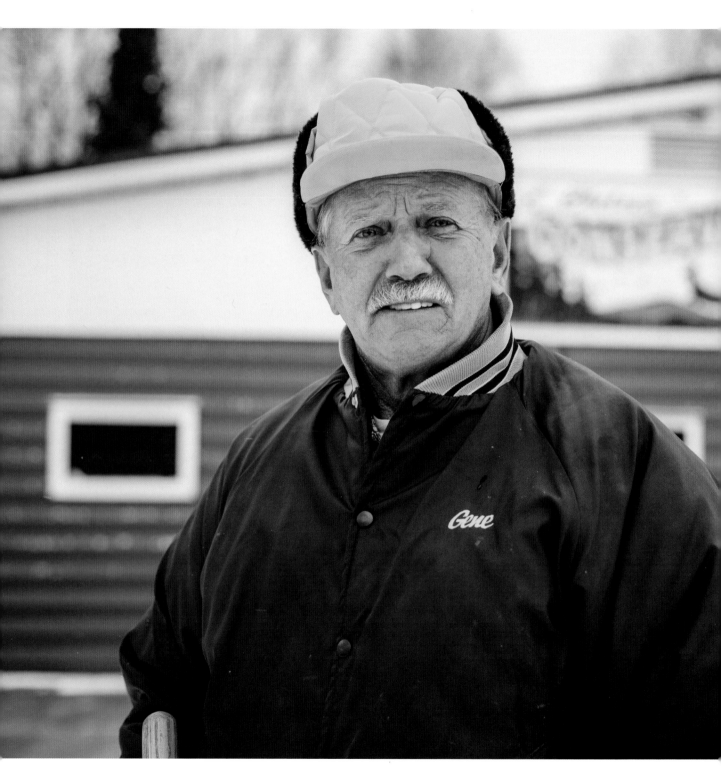

Gene, outside the Chelsea Conservation Club. The club serves as a registration station during the hunting season. Gene and his wife donate their time every year to registering deer kills.

A ring of registration bands lies on a convenience store counter, ready to band the next deer.

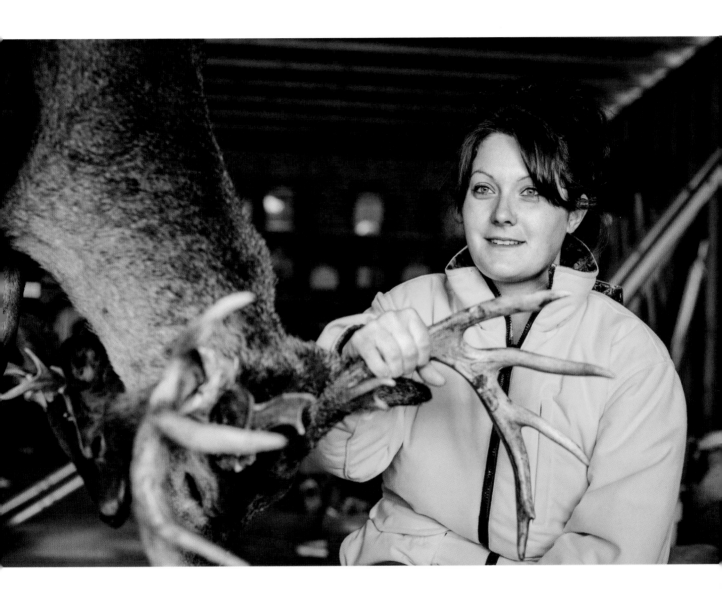

Kayla shot this buck right
away on Thanksgiving morning
and already had it back home
hanging in the garage.

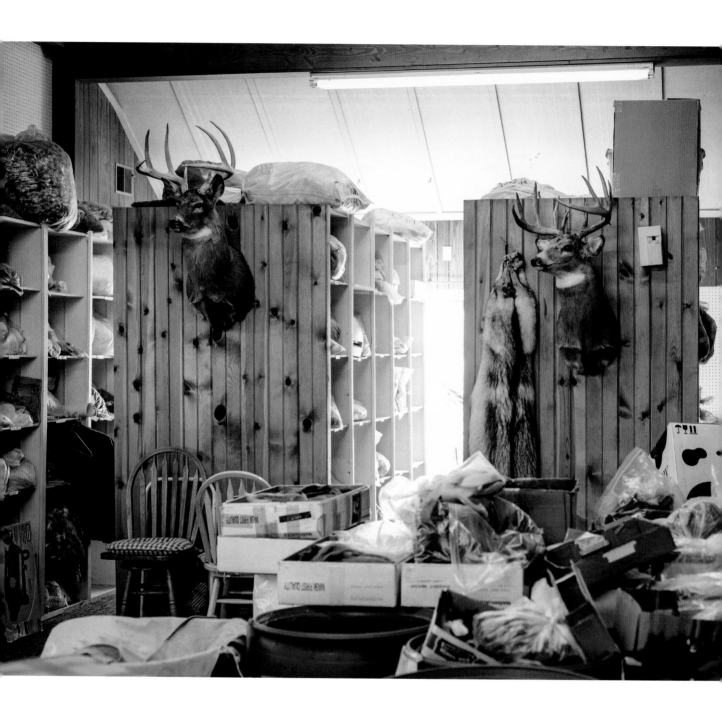

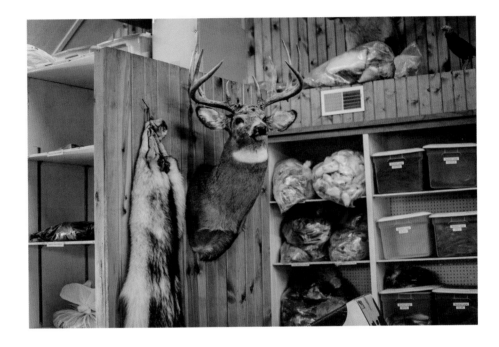

Dead dear are broken down
into many useful parts. At North
American Trading in Strum, shelves
hold dyed hide and fur from deer
tails to be used in fishing lures.

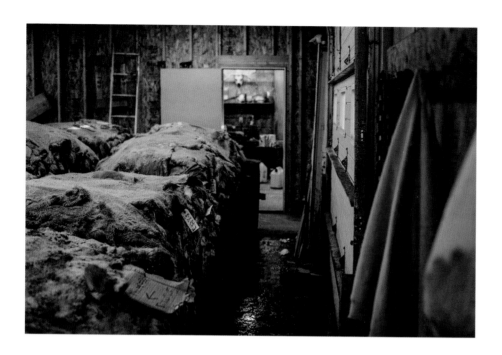

At a plant in Strum, pallets of cleaned and salted deer hides are stacked by the hundred. These will be shipped overseas to be used in gloves and other products.

Workers at the hide plant
personalize the empty walls.

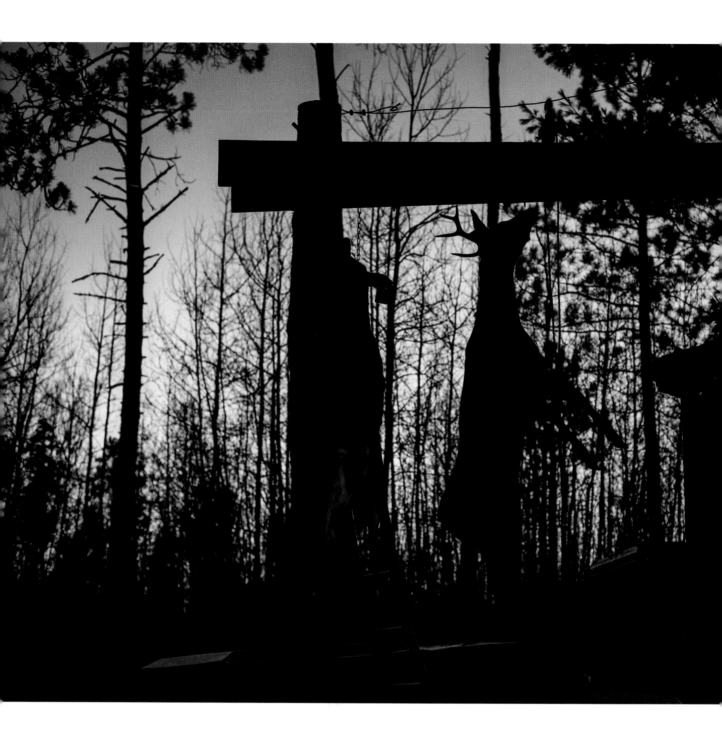

Deer hanging from trees
and poles are a common
sight this time of year.
Though they might look
uninviting in the evening
light, to a hunter they are
a mark of success.

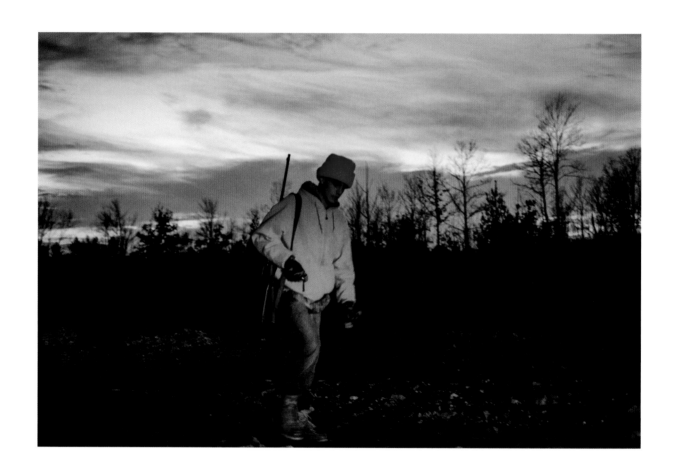

ABOVE: A young hunter makes his way out of the woods as the sun sets. OPPOSITE: A good day's work. Siblings Ryan and Kelsey pose with their grandfather, Don, next to their deer.

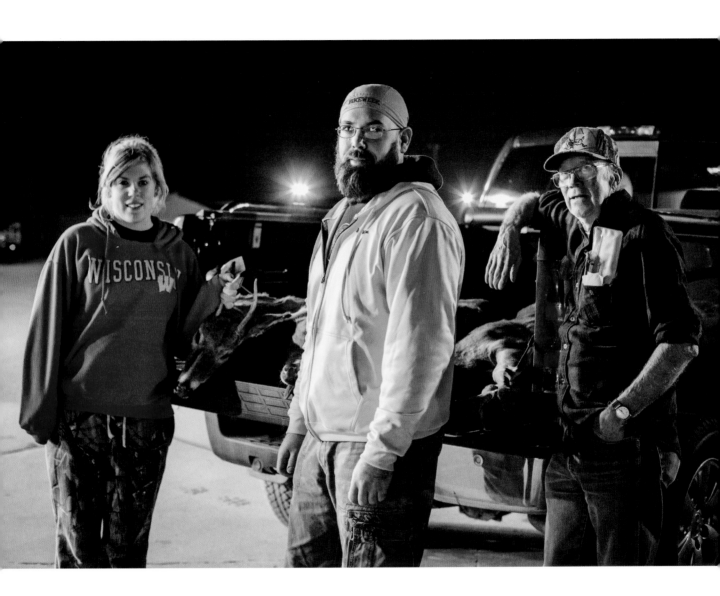

A popular place to set up camp is along US Highway 10 at Norm and Ann's Campground, outside Neillsville.

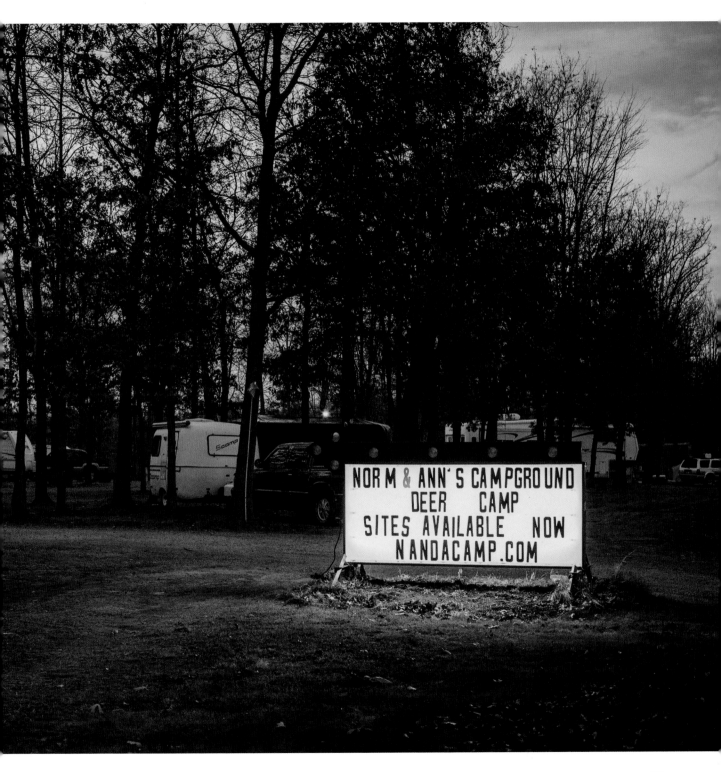

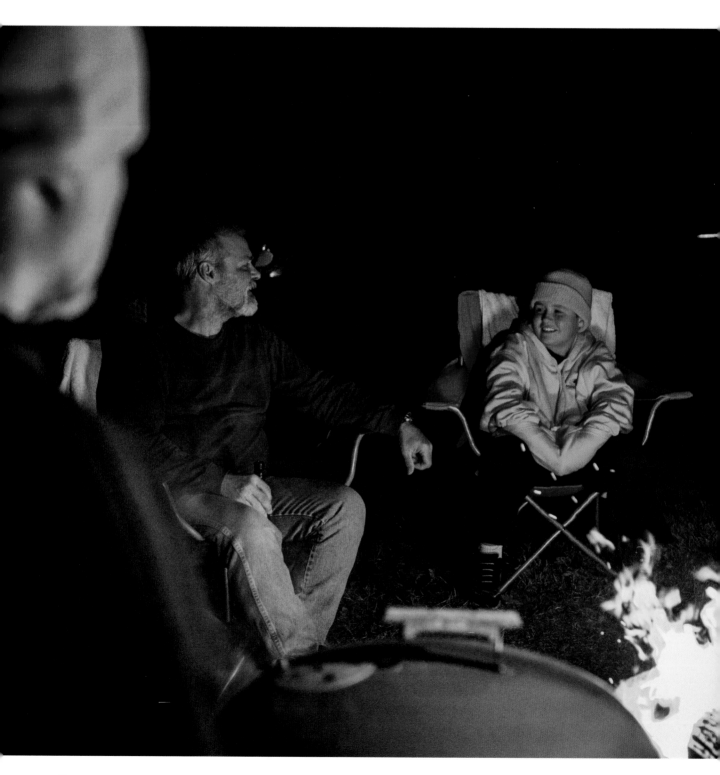

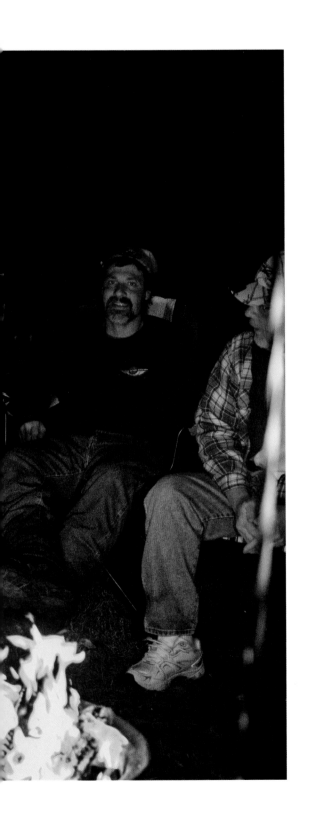

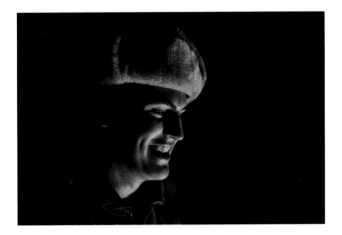

After a long, cold day in
the woods, hunters gather
for conversation and food.
The campfire is a welcome
sight this time of year.

Darkness brings the hunters
back to the cabin, where they
enjoy drinks and laughter.

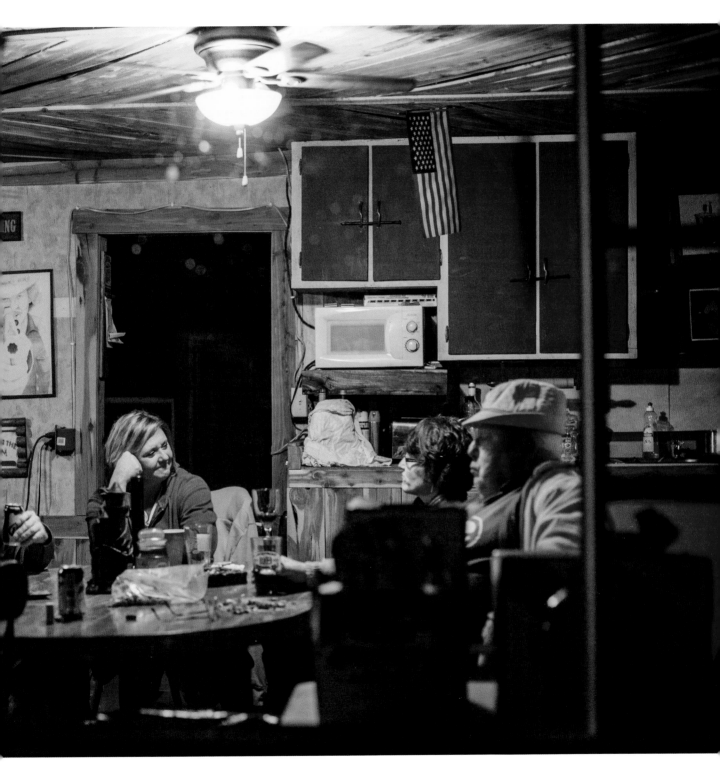

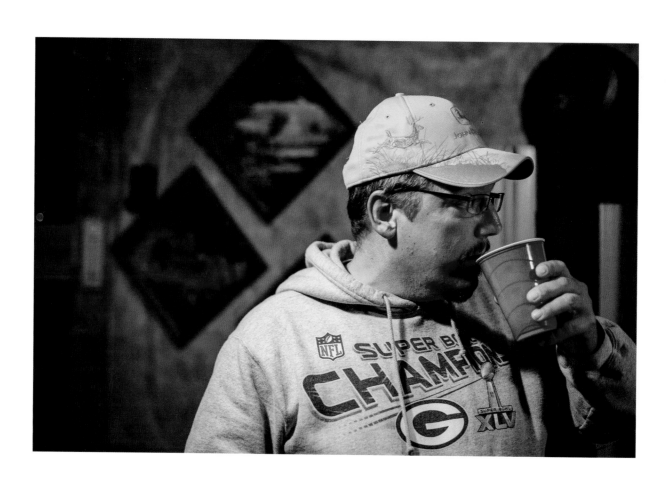

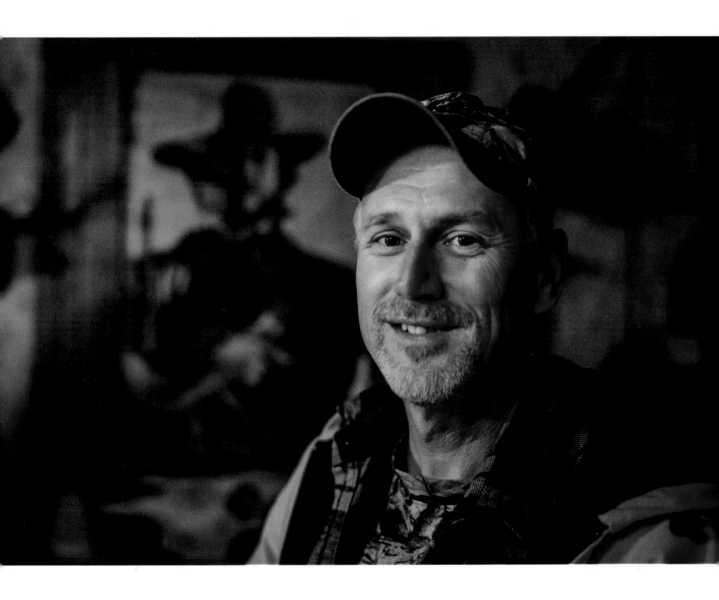

Al Biesterveld (left) and
Tony Bauer, Meridean

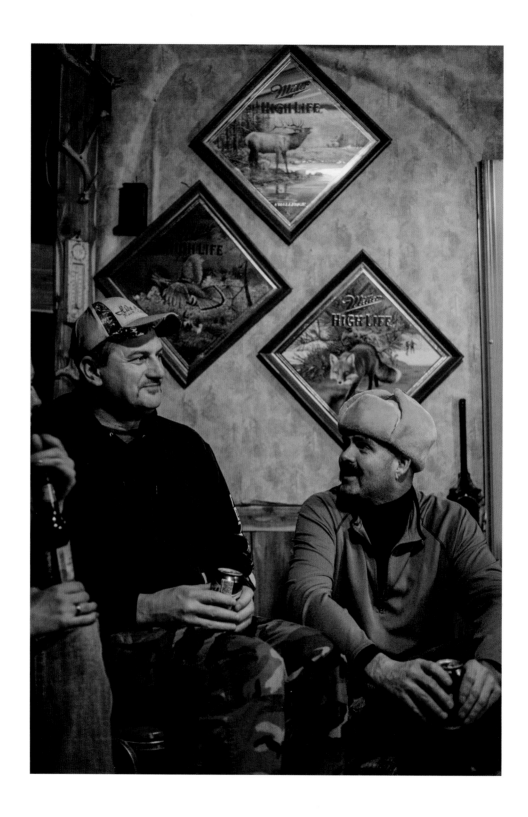

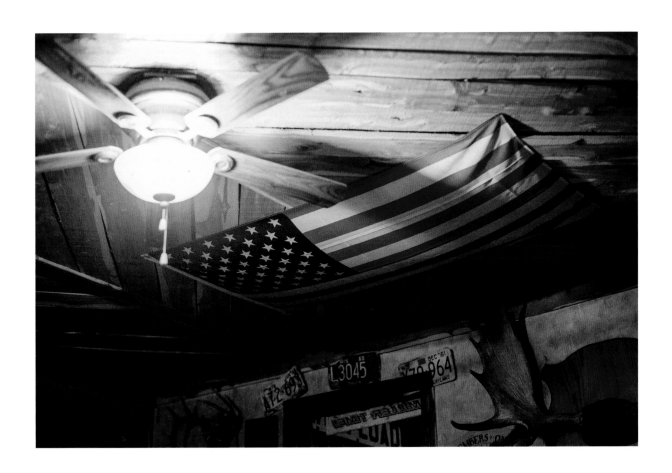

The insides of hunting cabins are
records of the past, with artifacts
such as old mounts and wildlife-
themed beer signs. Meridean.

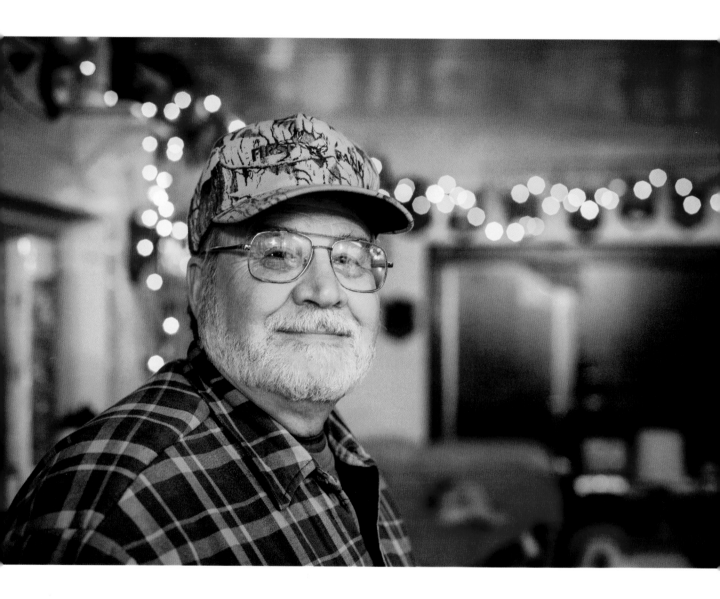

Ron, amid the warm red glow
that fills this small hunting
cabin on Marsh-Miller Lake
in Chippewa County

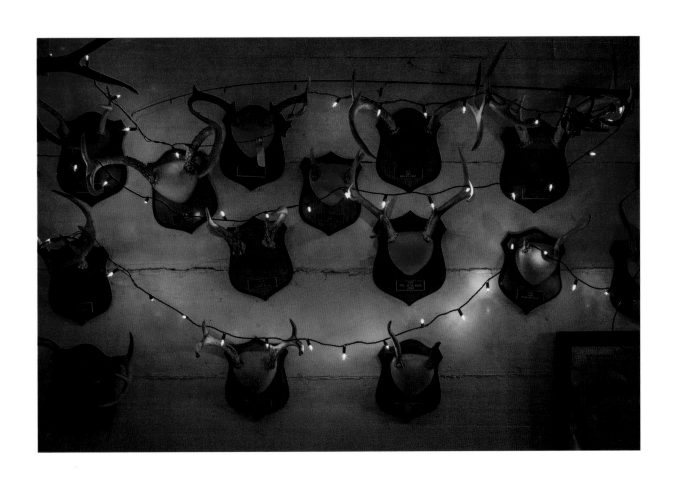

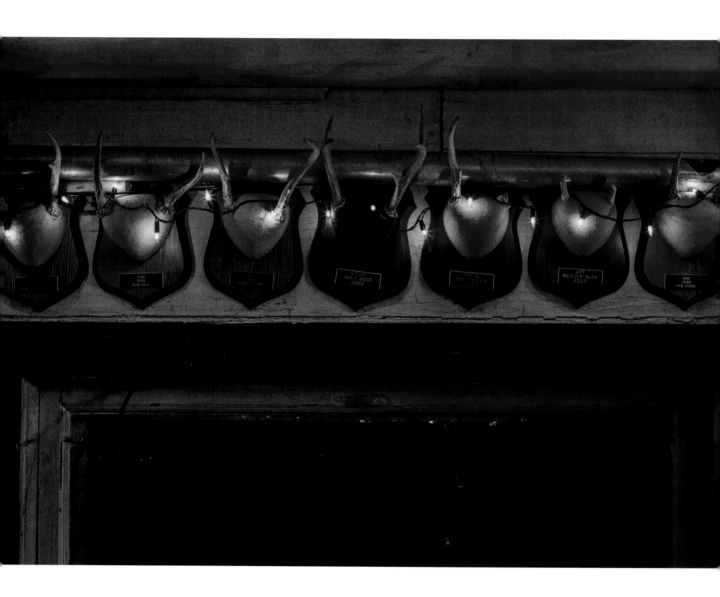

The plaques on these
antler mounts poke fun
at the members of the
group that hunts here.

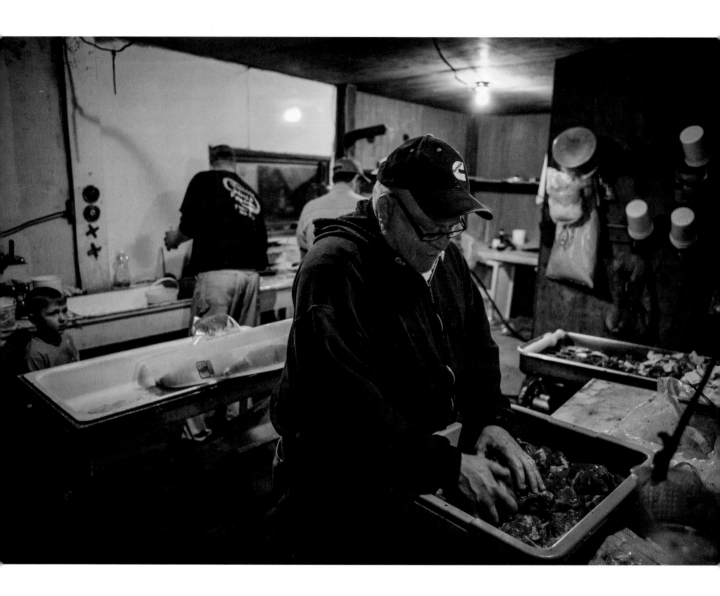

It's a family affair for the Helgesons
to make and smoke their own
venison sausages, ring bologna,
and wieners, near Gilmanton.

Grandpa Helgeson has his grandchildren help grind the venison.

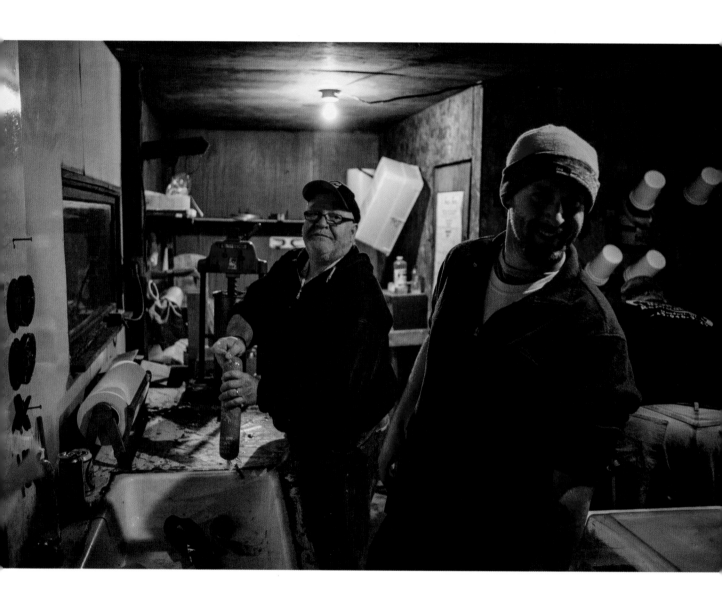

OPPOSITE: The night is filled with laughter and jokes as the men fill the sausage casings.
ABOVE: They hang the meat in the family's own smokehouse.

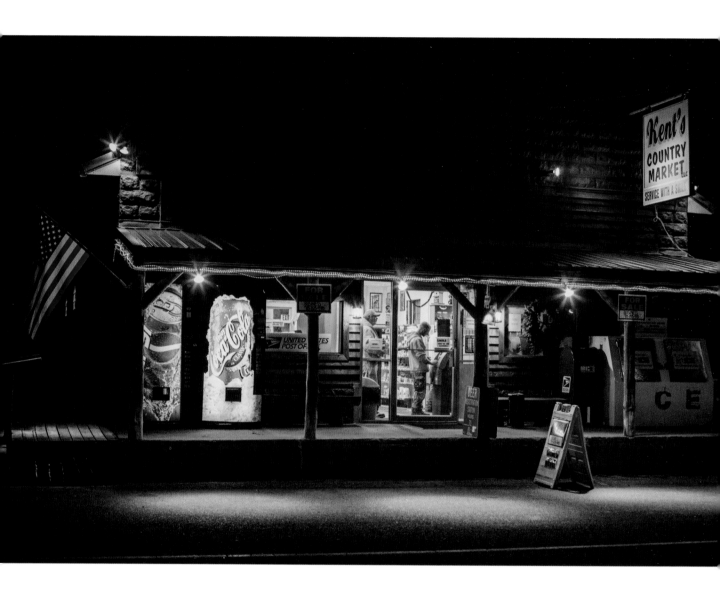

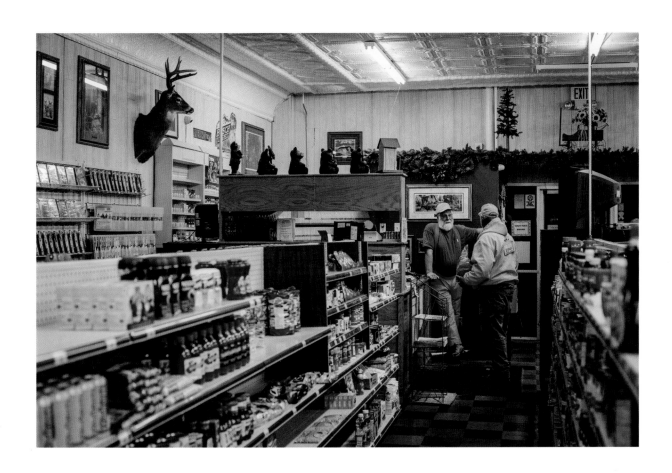

Kent's Country Market in Rock Falls stays busy with hunters. Until it closed in 2013, this was one of the few general stores in the state that still sported an original tin ceiling.

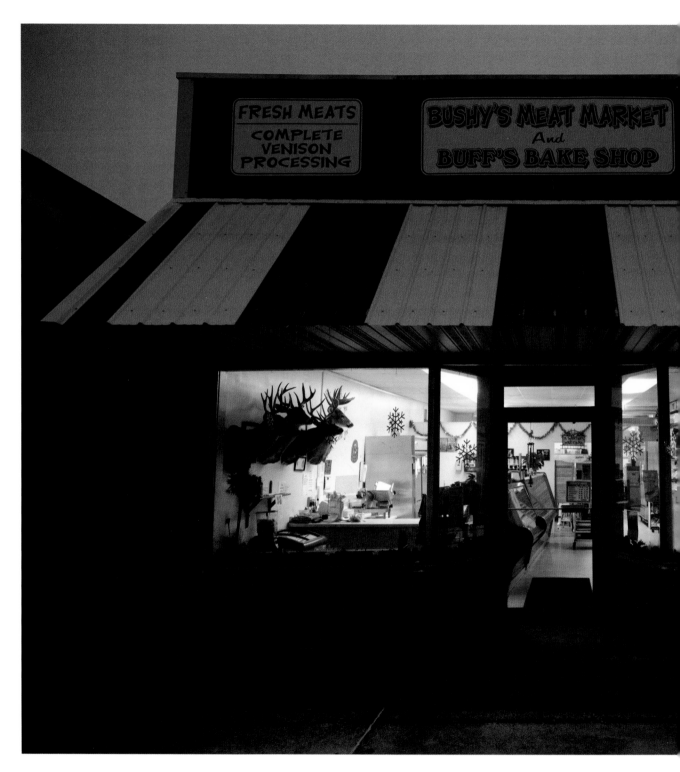

Bushy's Meat Market,
Independence

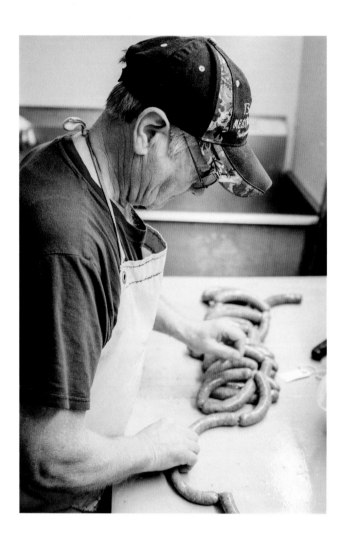

A sausage maker fills casings with seasoned venison and pork.

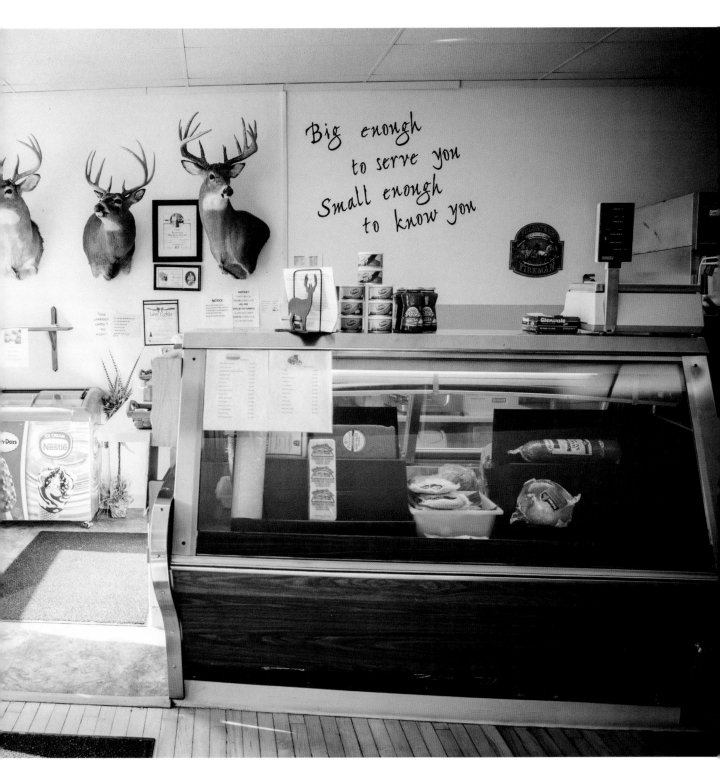

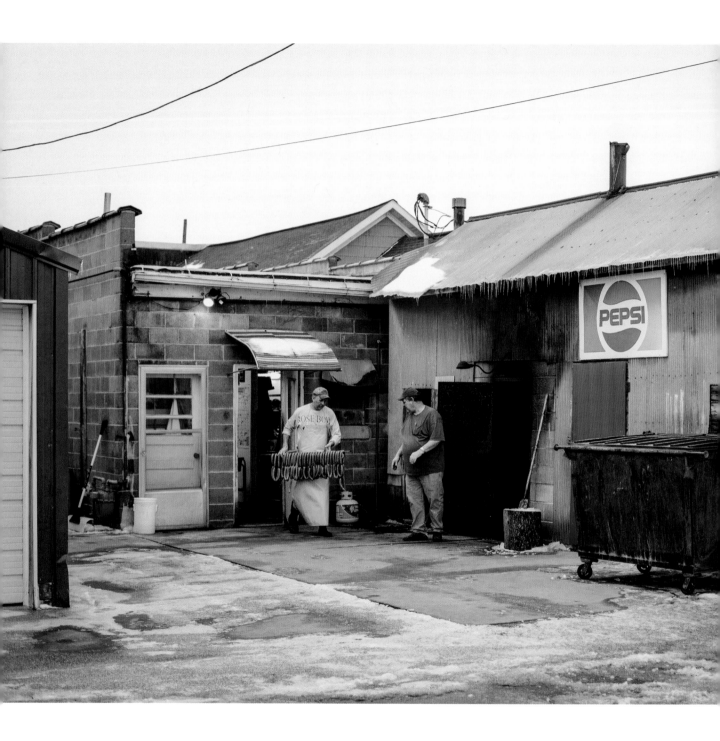

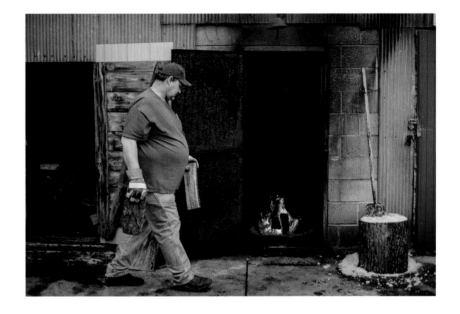

LEFT: The fire is stoked as racks of venison sausage are brought out to be hung in the smoke-house. **ABOVE**: Bushy puts a few more pieces of hickory and cherry on the fire.

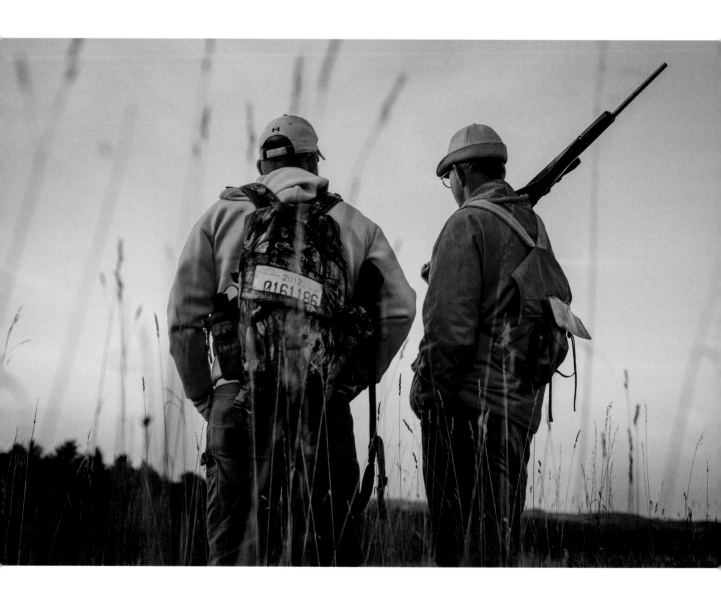

Two hunters look down on a valley near Fall Creek just before sunrise as they quietly discuss their plans.

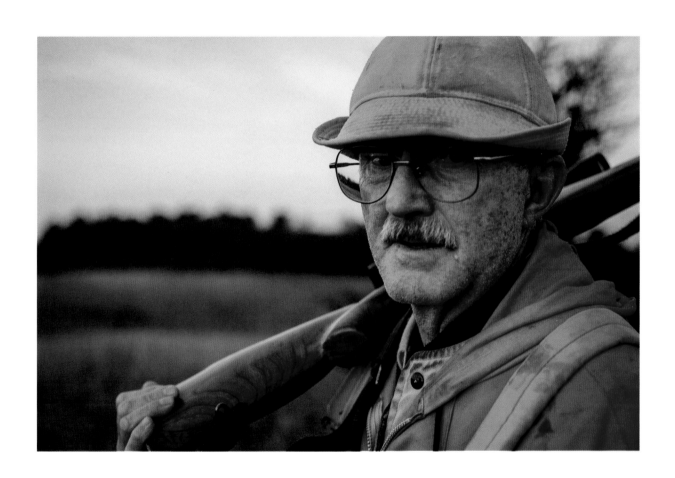

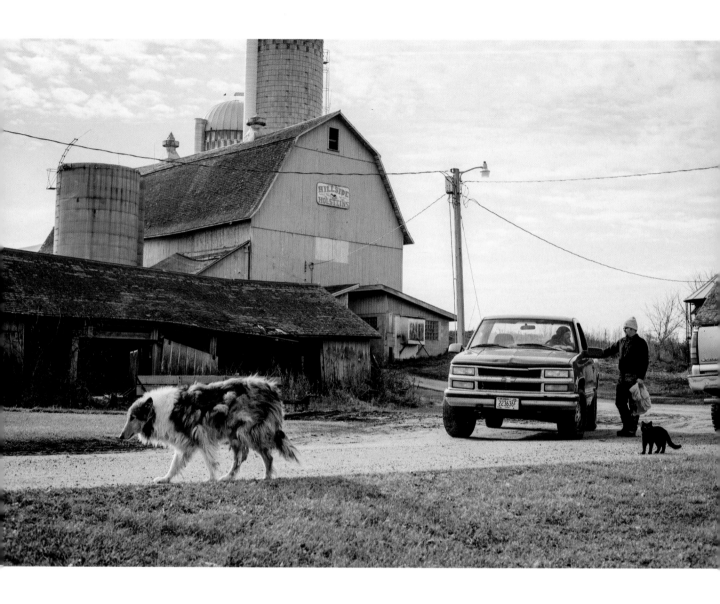

ABOVE: Getting ready to leave the farm for a few hours of hunting before chores, Mikana. **OPPOSITE:** Last year's European mount, near Taylor

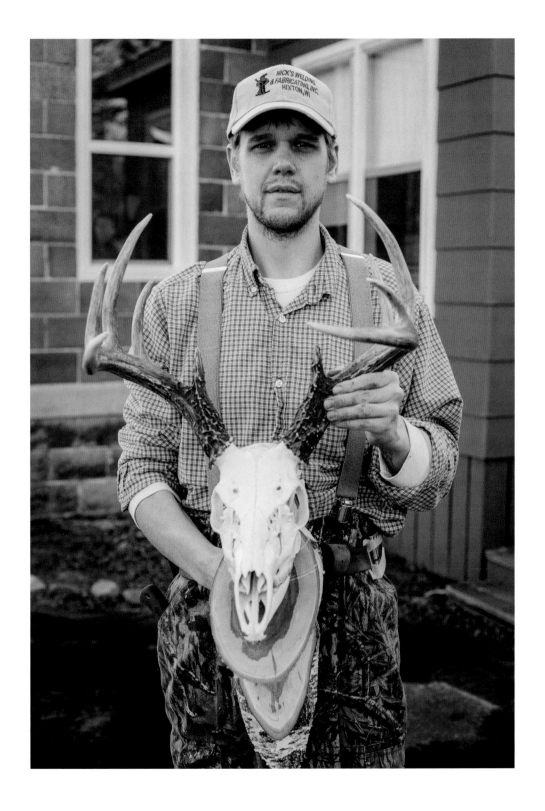

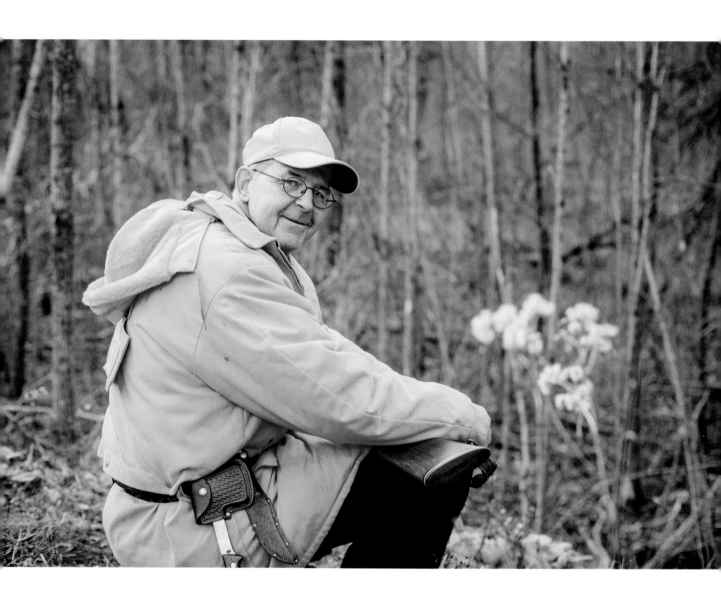

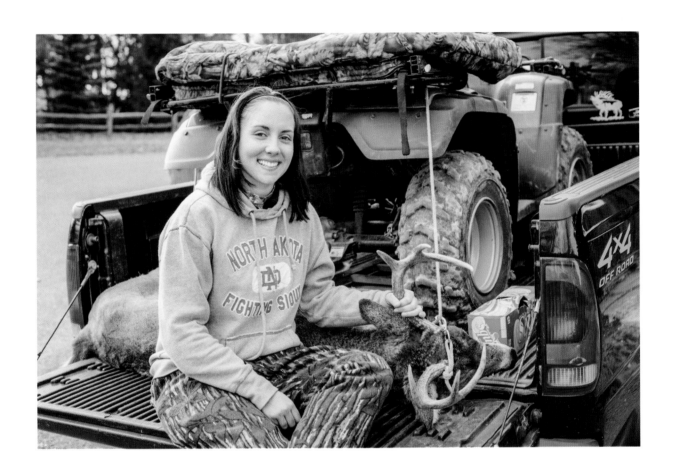

OPPOSITE: Steve enjoys the peaceful woods as he sits on a stump overlooking a thicket in the Benson Creek State Wildlife Management Area in Sawyer County. ABOVE: Shanna with a buck she shot up north, ready to head back to La Crosse

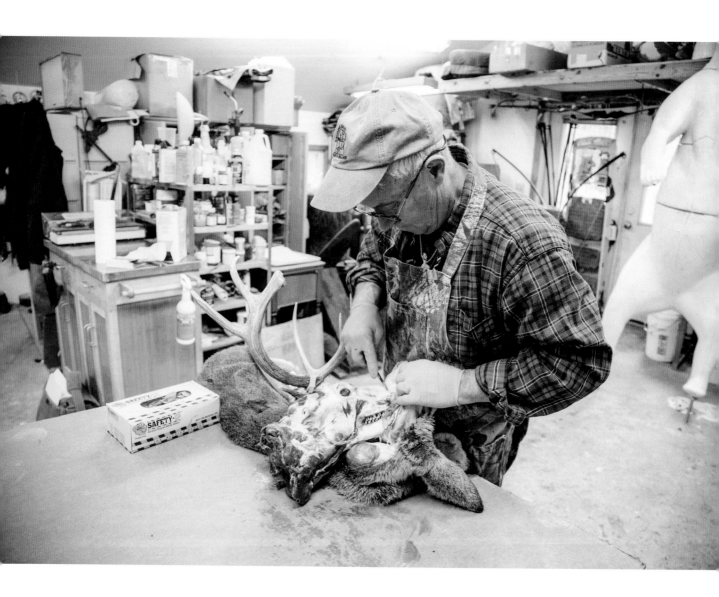

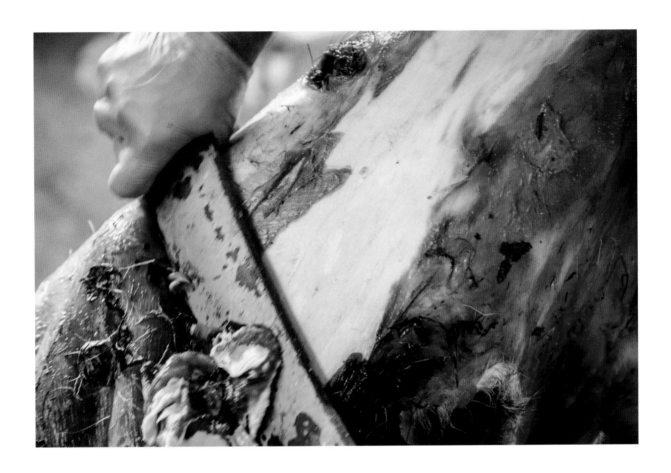

OPPOSITE: Jack Dodge, owner of Dodge Taxidermy near Elk Lake, at work. ABOVE: Dodge starts a deer mount by removing the hide and as much flesh as he can. The skull is then placed in a container with Dermestid beetles, which eat away any remaining tissue. Once cleaned, the mounting process can continue.

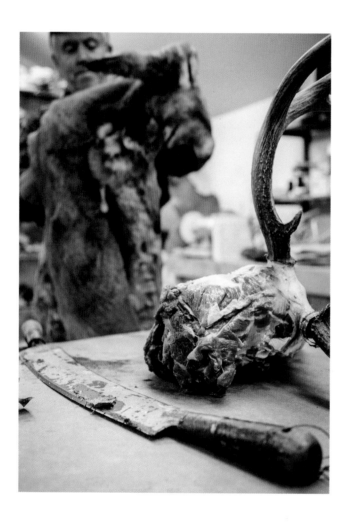

ABOVE: The hide also needs to be prepared before it can be mounted. After being stripped, it is salted to pull out any remaining moisture.
RIGHT: Dodge with some of his work. Among the mounts behind him is a full whitetail deer.

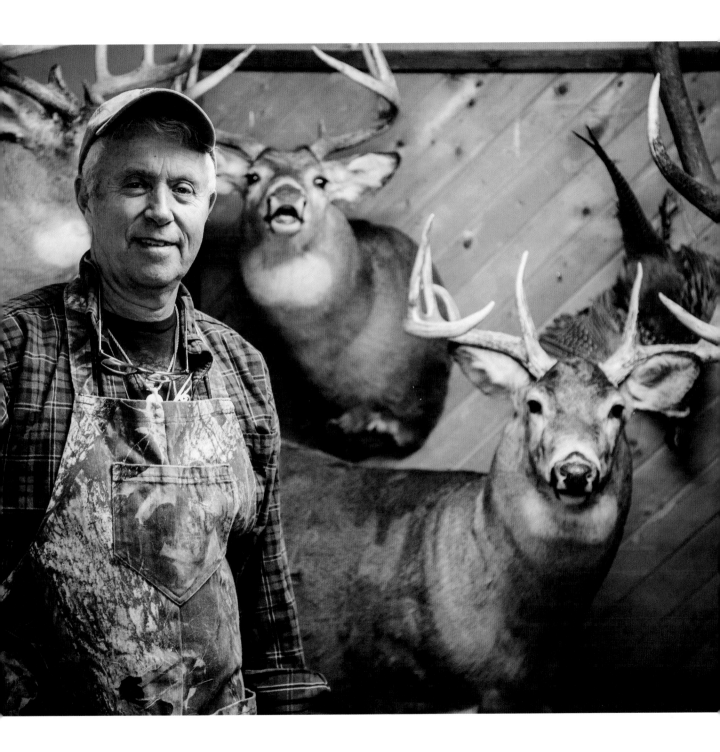

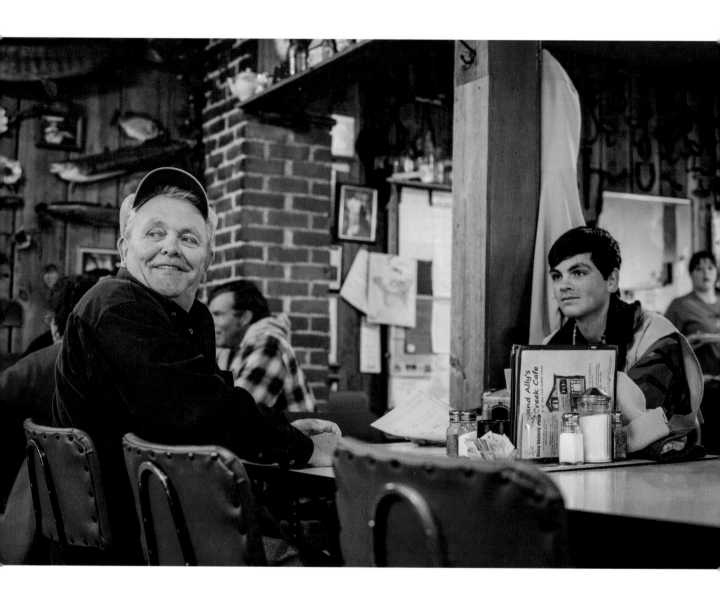

At the Sand Creek Café, grandfather and grandson
share a late-morning breakfast. The young man's
father is in the military and was not able to make it
back to Wisconsin for the season.

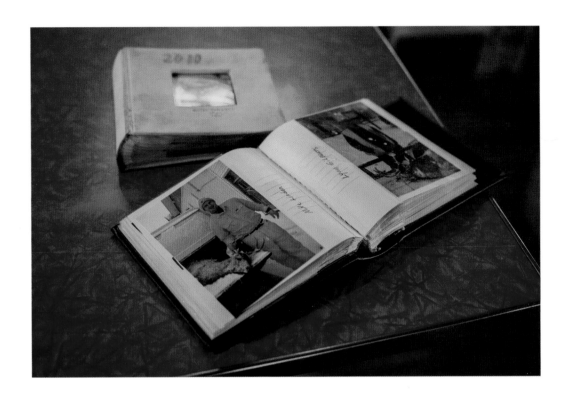

Photo albums from previous years' big buck contests. Many places I visited had a similar album or stash of photos.

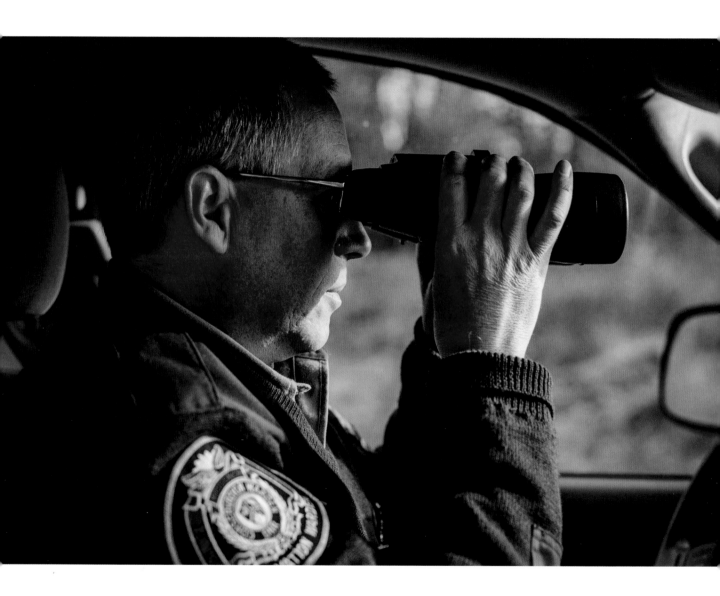

The deer season is a busy time for the Department of Natural Resources. Agents watch out for rule violations and make sure everyone has a safe hunt. I rode with game warden Scott Thiede as he patrolled Eau Claire County.

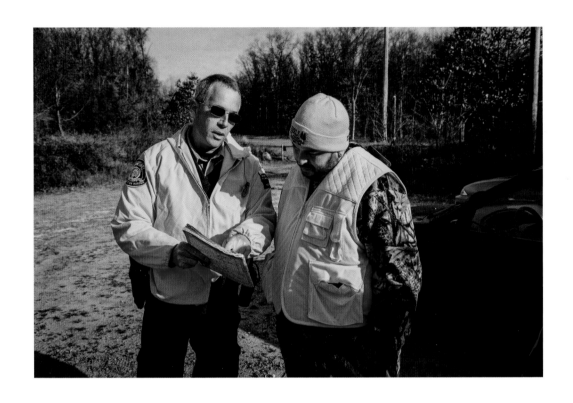

Warden Thiede shows a local hunter the boundaries of the Eau Claire County public hunting area on a map.

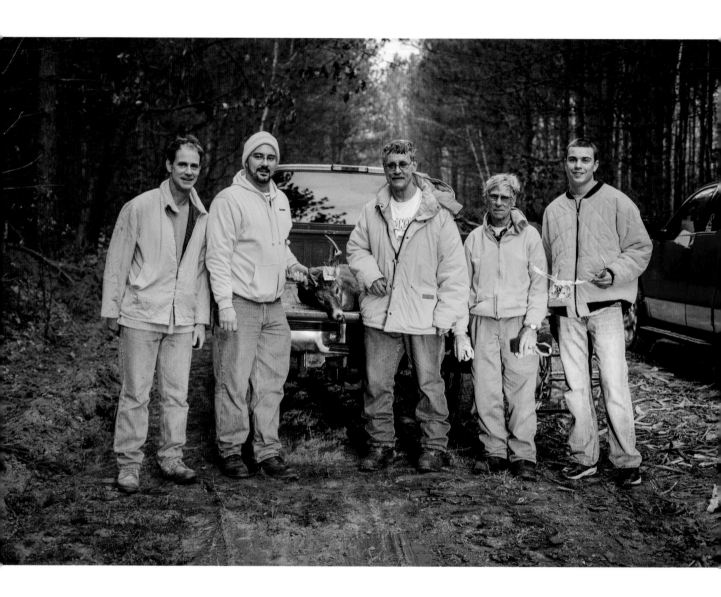

ABOVE: Three generations of hunters stop
for a photo at the back of their pickup
truck. OPPOSITE: Happy to be in the woods
another year with his sons and grandson

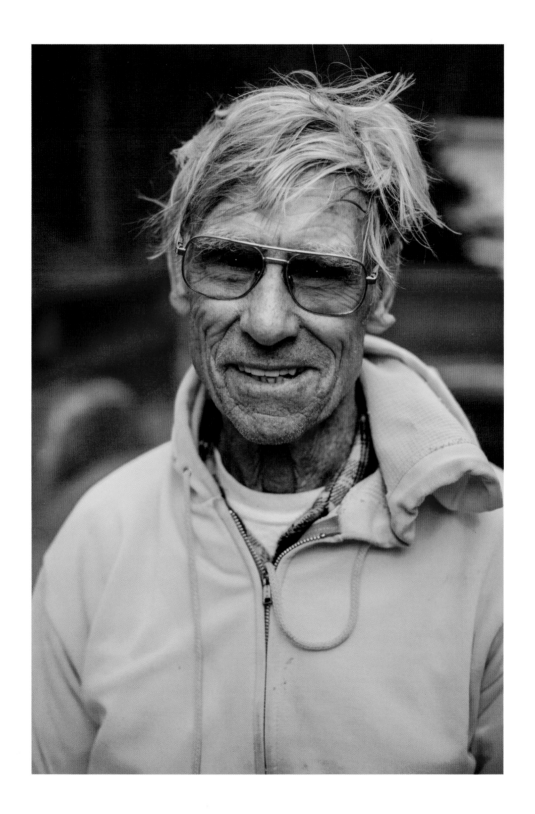

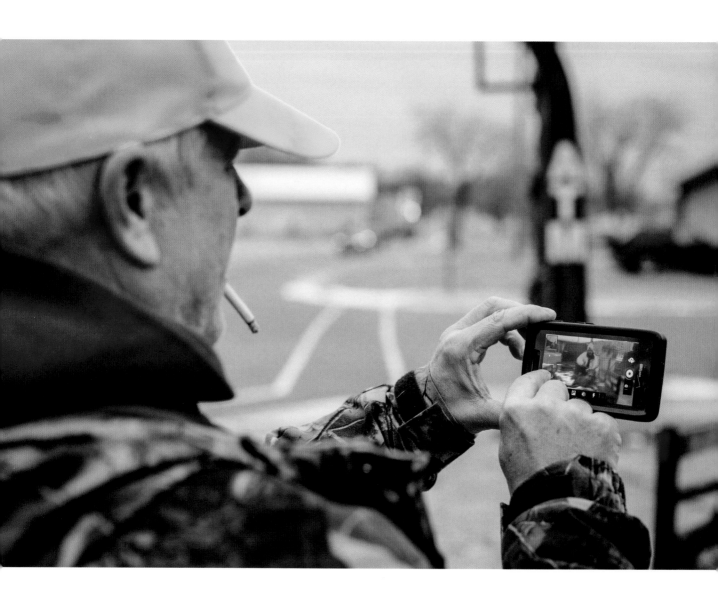

The digital age has crossed over
into hunting, as Al takes a photo
of his son Matt with a buck.

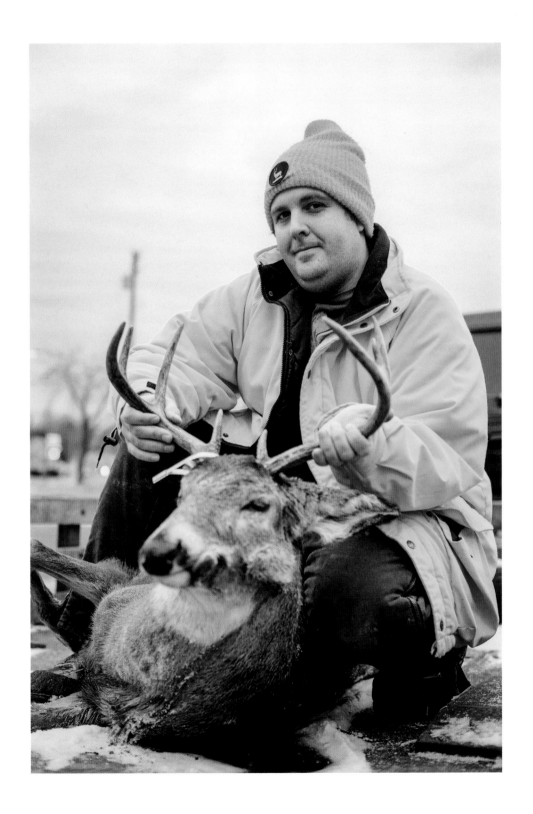

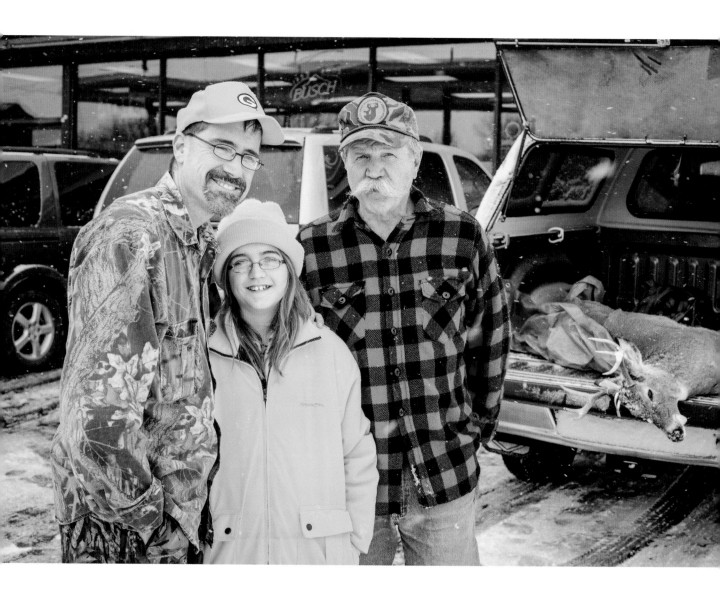

OPPOSITE: Two very proud men with their thirteen-year-old hunter's first deer, registering the kill at Ball Petroleum in Phillips.
ABOVE: I saw many more girls out with their families than I would have ever expected. I also didn't expect to see Santa this soon at OW Sports & Liquor in Owen.

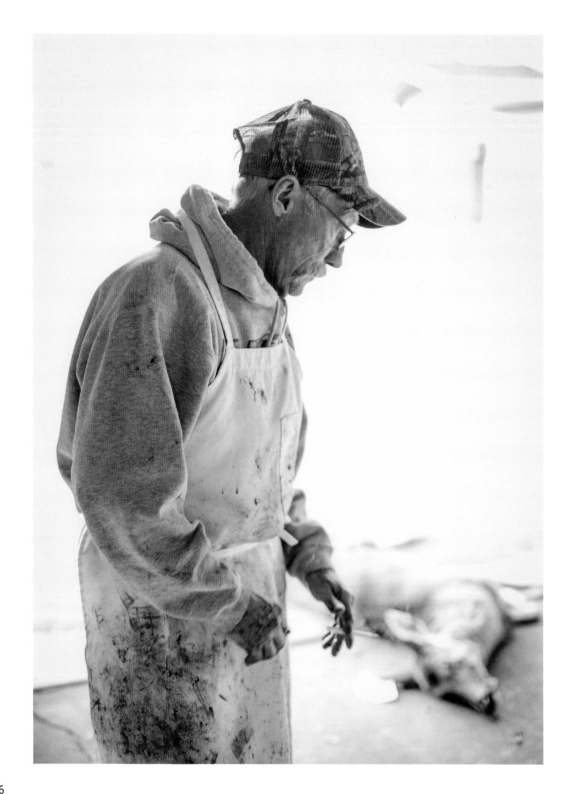

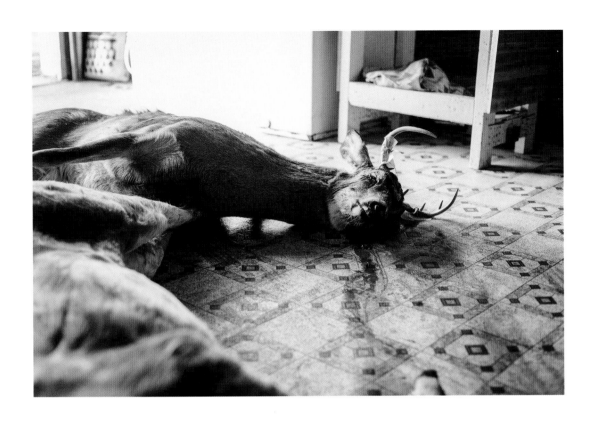

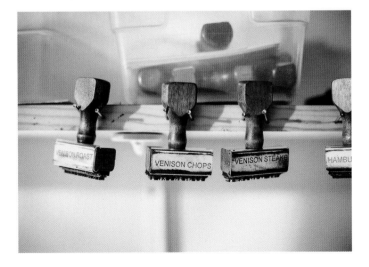

OPPOSITE: Harry of Harry's Deer Processing in Osseo. RIGHT: Stamps are used to label cuts of meat once they are prepared and wrapped in white freezer paper.

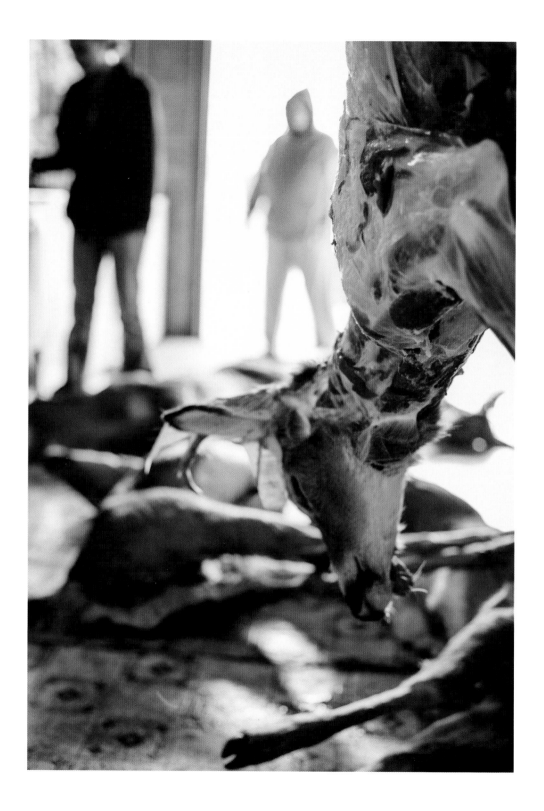

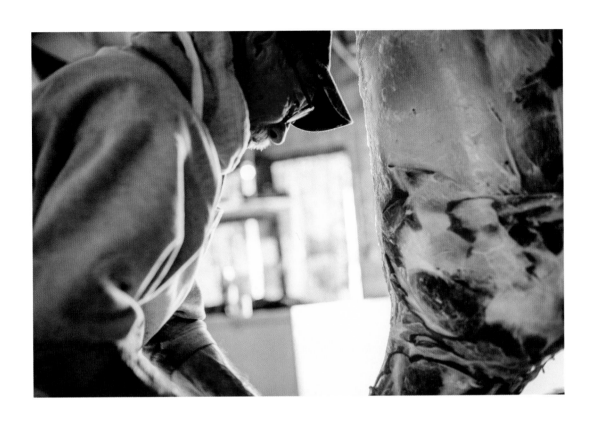

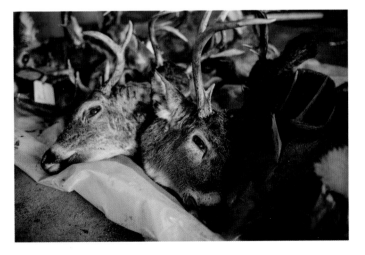

Harry proudly says what you bring in is what you get. He doesn't mix any of the meat, so each hunter is sure to receive exactly what he or she killed.

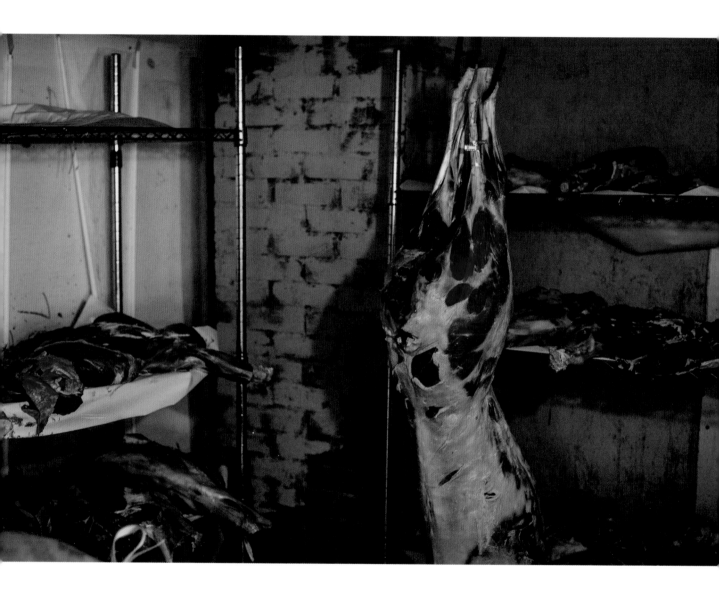

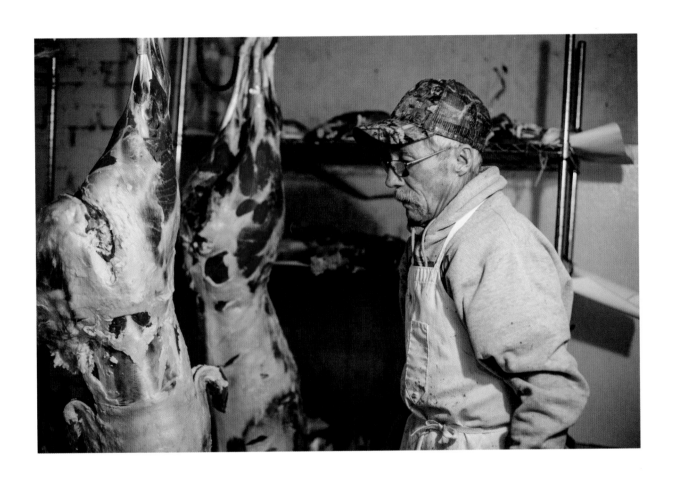

During the season, deer arrive at the butcher at a fast rate. Harry works quickly to prepare the carcasses and get the meat into the freezer.

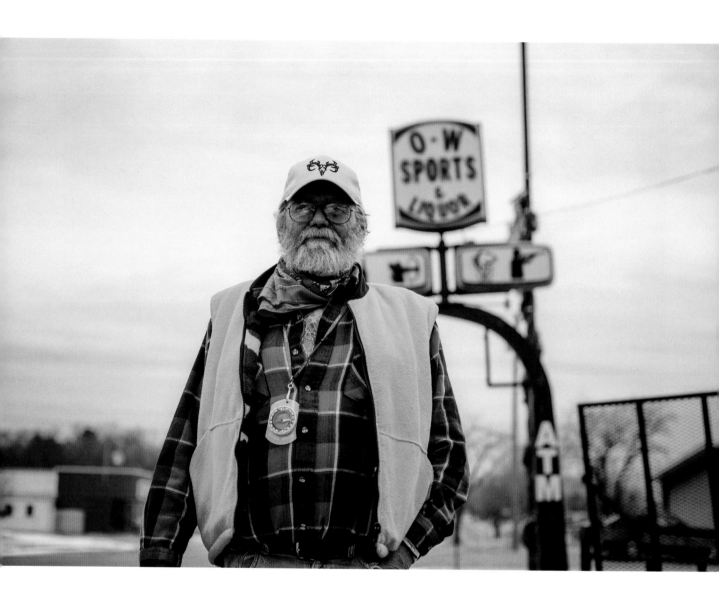

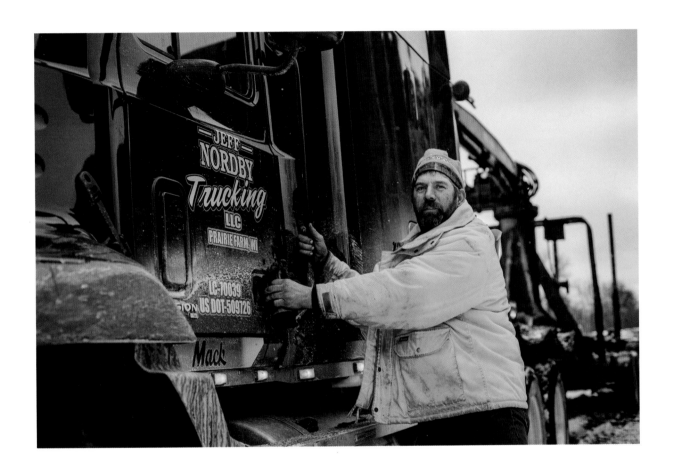

OPPOSITE: Tom, owner of OW Sports & Liquor in Owen, stands outside his shop. ABOVE: Randy wore blaze orange to stay safe while at work transporting logs near Hayward. He was hoping to find some time yet to make it back out to hunt.

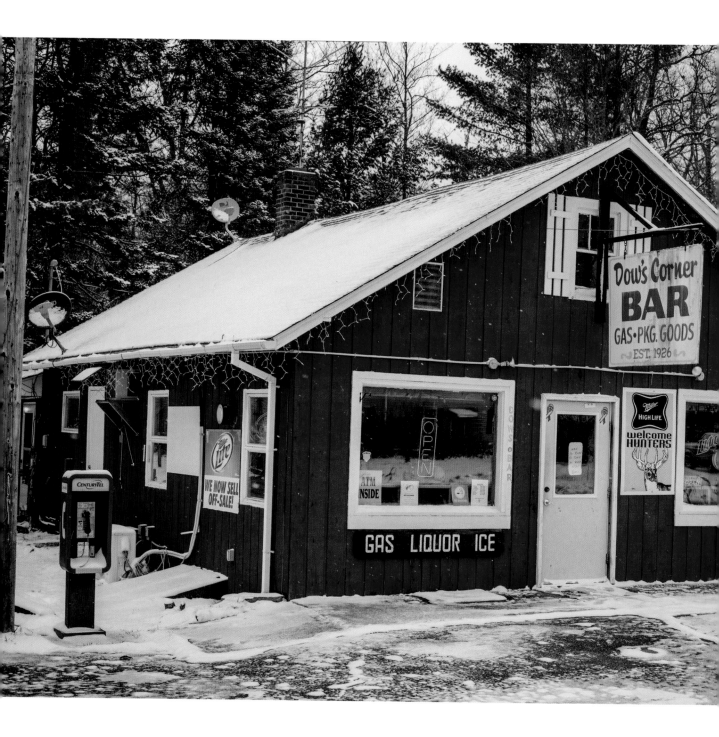

Dow's Corner Bar in Clam
Lake. Blaze orange beer
signs urge hunters to
come in from the cold.

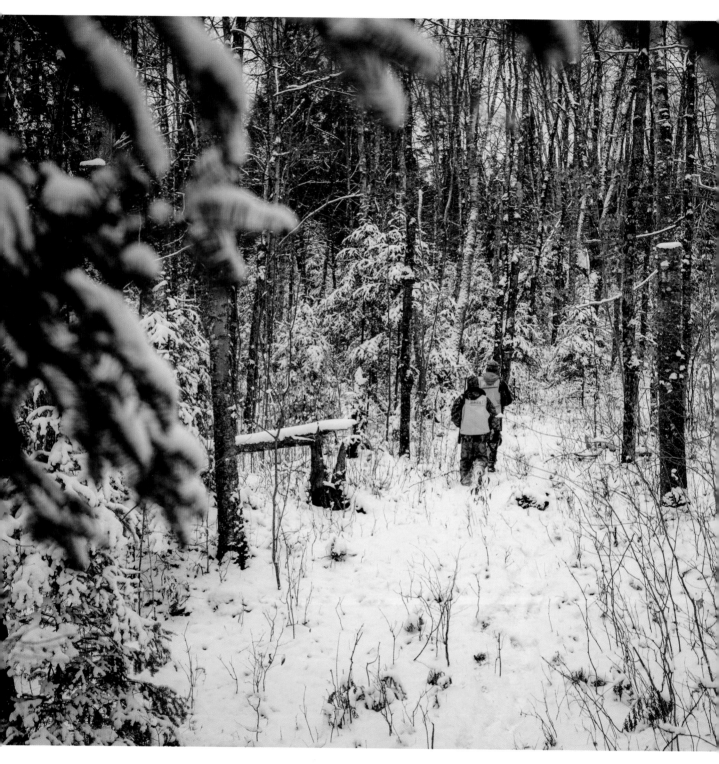

Fresh snow is welcomed by many hunters as it improves visibility through the trees. These two walk deep into the Chequamegon National Forest.

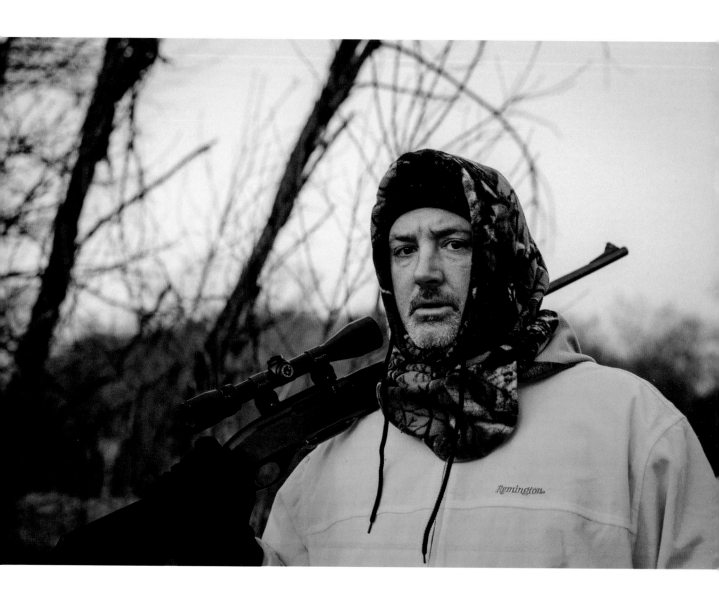

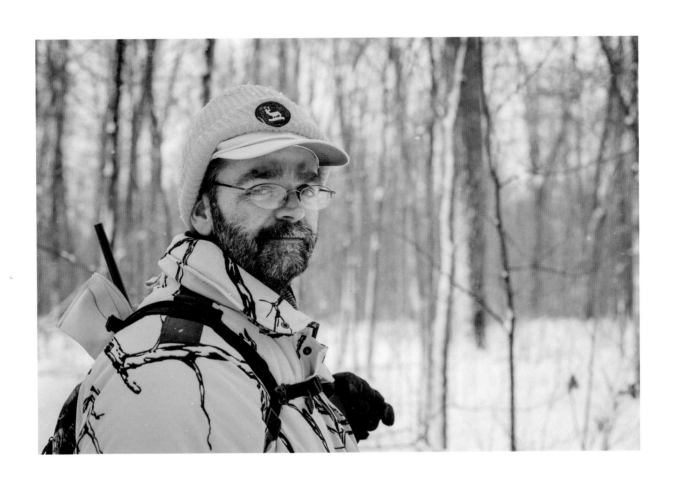

OPPOSITE: Chris, near Mondovi
ABOVE: Darren, outside Glidden

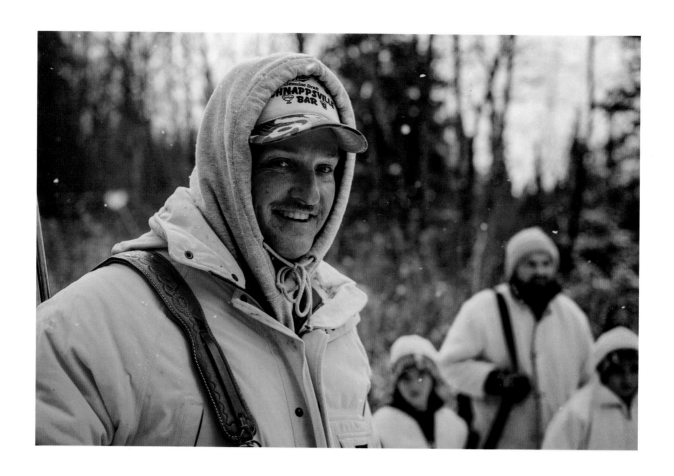

A group of hunters sets
out west of Rib Lake.

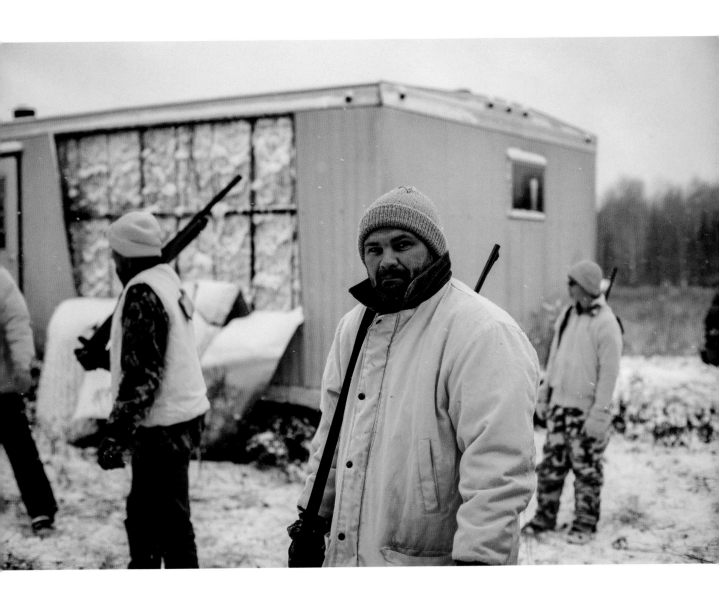

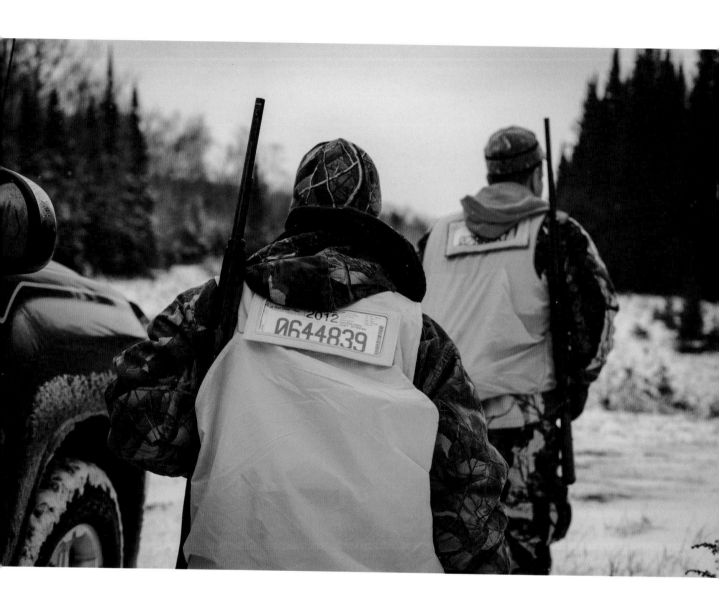

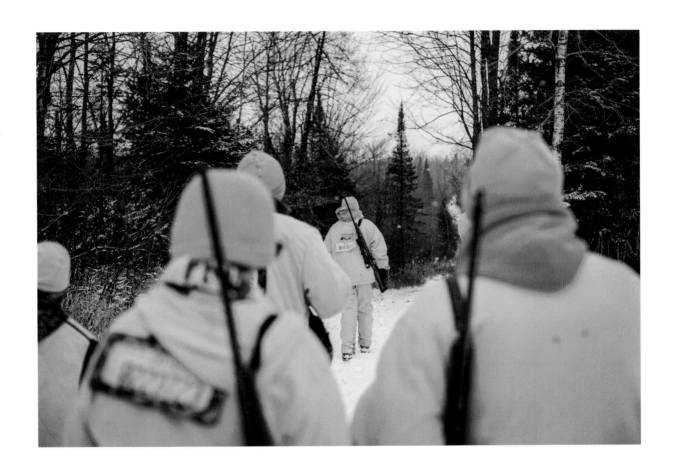

ABOVE: Hunters walk into the woods together before splitting off to go their own ways. Chequamegon National Forest, near Clam Lake.
OPPOSITE: West of Rib Lake

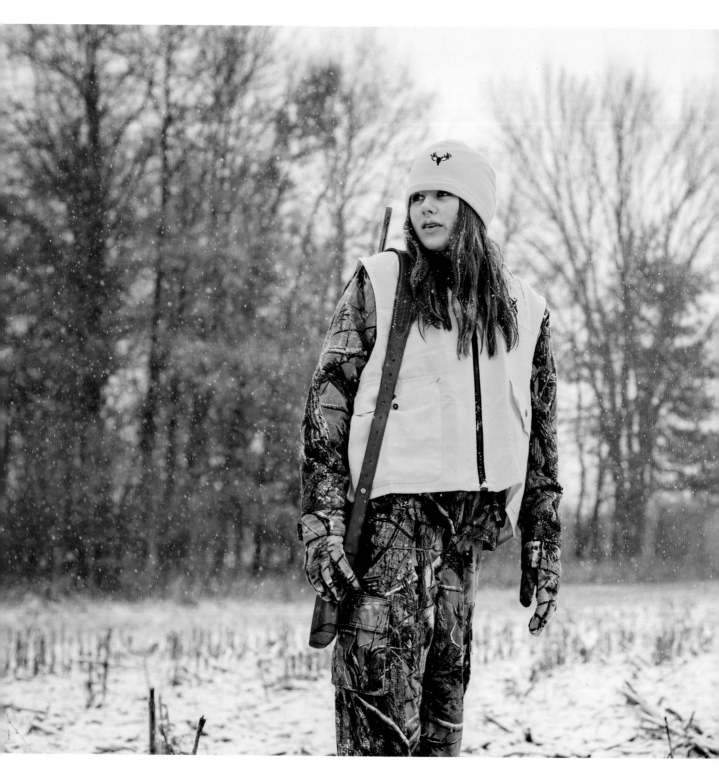

Kailee looks across a
harvested corn field for
any signs of movement.

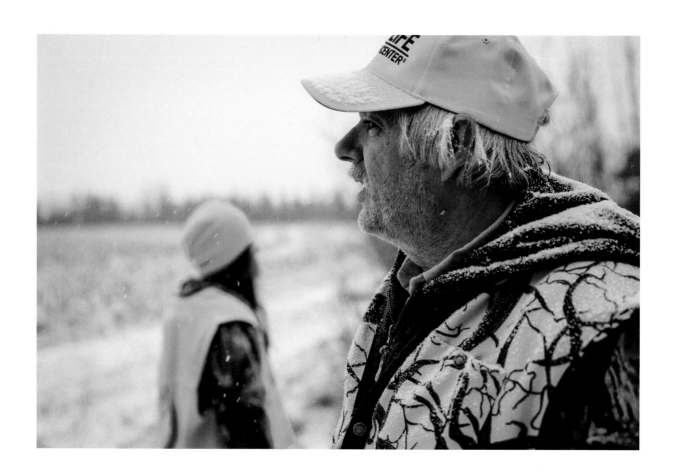

Craig passes down his hunting
knowledge to his granddaughter—
all except his secret spots, he says.
South of Cadott.

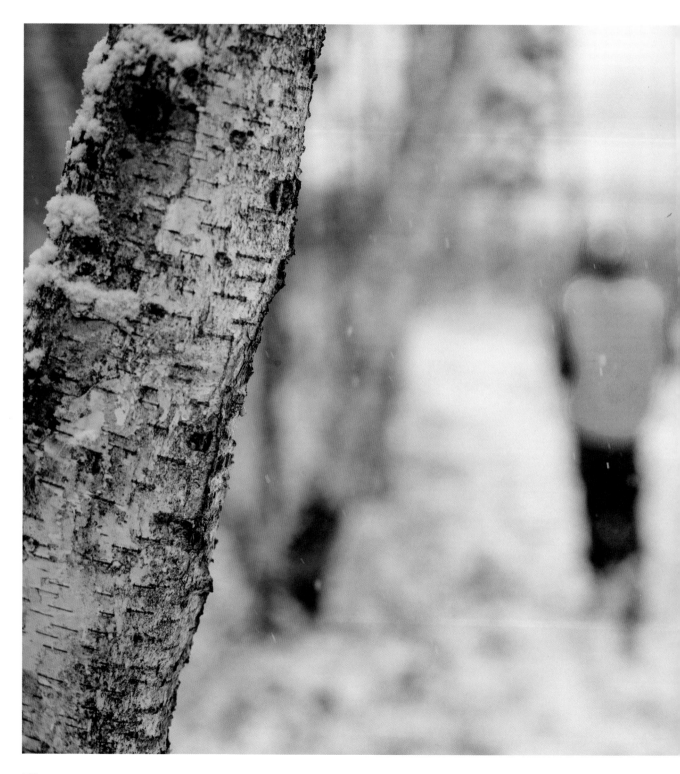

At the end of the season, successful or not, hunters carry with them memories of time with friends and family, getting away to the cabin, or just hearing the wind rush through the trees.